IMAGES
of America

SAVAGE

IMAGES
of America
SAVAGE

Nancy Huddleston

ARCADIA
PUBLISHING

Copyright © 2012 by Nancy Huddleston
ISBN 978-0-7385-9055-4

Published by Arcadia Publishing
Charleston, South Carolina

Printed in the United States of America

Library of Congress Control Number: 2011944553

For all general information, please contact Arcadia Publishing:
Telephone 843-853-2070
Fax 843-853-0044
E-mail sales@arcadiapublishing.com
For customer service and orders:
Toll-Free 1-888-313-2665

Visit us on the Internet at www.arcadiapublishing.com

This book is dedicated to all of the residents of Savage, in particular those who have kept the history of the city alive throughout the years.

CONTENTS

ACKNOWLEDGMENTS

The Dan Patch Historical Society is made up of a small group of volunteers who are dedicated to accurately portraying and promoting the history of the city of Savage. If not for their hard work, this book would not be possible.

Everyone at the Dan Patch Historical Society—in particular Jens Bohn, president; George Augustinack, vice president; Janet Bohn Williams, secretary; and members Wilfred Williams and Jim Ross—contributed to the success of this book. Other community members like Mark Roberts, Mary Margaret McQuiston, Terry Kearney, Ray Egan, the late Mary Pat Suel Kearney, and the late Ed McQuiston also contributed to this book with photographs and information they have compiled over the years.

Other contributors include the late Joe Egan, who was known as "Mr. Dan Patch." He was famous for his devotion to the history of the racehorse Dan Patch and his owner, Marion Willis Savage. His dedication to the community was mirrored by the late A.C. "Dell" Stelling, a newspaperman who helped found the Dan Patch Historical Society. Dell also kept history alive through his many newspaper articles and photography features in the *Dakota County Tribune*, *Minnesota Valley Review*, and the *Savage Review*.

The Savage Library and its staff, in particular Vanessa Birdsey and Deb Kahlow, also contributed to this book by providing guidance and assistance whenever needed. The majority of the photographs and information printed here came from the Heritage Room collection at the library, which is part of the Scott County Library System.

The City of Savage also provided information for this book by researching files. Thanks especially to communications director Amy Barnett and city clerk Ellen Classen.

Other authors who have written books about Dan Patch and Marion Willis Savage are commended for their works, because their research helped accurately tell the stories printed here. Those authors include Tim Brady (*The Great Dan Patch and the Remarkable Mr. Savage)*, Charles Leerhsen (*Crazy Good*), Deborah Savage (*To Race a Dream*), Fred Sasse (*The Story of the Great Dan Patch*), and Willis Ackerman (*Dan Patch/M.W. Savage Update, Collector's Handbook*). Information reported in the *St. Paul Pioneer Press* and *Minneapolis Star Tribune* was also used as a resource for this book.

The weekly community newspaper the *Savage Pacer* also played a vital role in the success of this book. As a former editor of the *Pacer*, author Nancy Huddleston developed her love for the city's history while working there. The *Pacer* is owned by Southwest Newspapers.

Unless otherwise noted, all images in this book appear courtesy of the Dan Patch Historical Society, from its collection housed in the Heritage Room at the Savage Library.

INTRODUCTION

Throughout history, the communities known as Hamilton, Glendale, and Savage were shaped by transportation connections, from wagon trails to river steamboats and on to railroads and roads.

Before white settlers arrived, the area around Savage was home to the Black Dog Indian village. The journeys of the Indians created paths, which settlers eventually followed from the river to Hamilton. French fur traders came to the Larpenteur Fur Company of St. Paul, located on the Credit River. In 1852, a small trading post was established at the junction of the Credit River and the Minnesota River.

Shortly afterward, Hamilton Landing was built on the banks of the Minnesota. This is where many Scottish and Irish settlers exited the steamboat they had boarded at Fort Snelling and set up a village named after the river landing.

In 1865, at the conclusion of the Civil War, railroading got its start in Hamilton. The first railroad tracks were laid in August 1865 toward a junction with the Minnesota Central Railroad in Mendota. Tracks were extended to Shakopee, and the first steam locomotive in the state of Minnesota, the Mankato, completed its first trip from Hamilton to Mendota in October of that year. One year later, a post office was constructed in the village. In 1880, the Savage Depot was built by the Chicago, Minneapolis & Omaha Railroad.

While Hamilton continued to establish itself as a rail and river town, an entrepreneur by the name of Marion Willis Savage was building an empire across the river. He was the founder and owner of the International Stock Food Factory in Minneapolis, which manufactured and sold animal feed and veterinary supplies.

In 1902, Savage purchased a pacer named Dan Patch for $60,000. He was housed with Savage's other famous horses on the International Stock Food Farm, built on the banks of the Minnesota River in Hamilton in 1904. The complex, nicknamed the "Taj Mahal," included a one-mile track, a covered half-mile track, and a heated stable with a mosque-shaped dome. Although Savage lived in Minneapolis, his summer home, Valley View, was located on the north bank of the Minnesota River in Bloomington, which gave him a perfect view of the farm in Hamilton.

Savage heavily promoted Dan's races and used the horse's image in many of the advertisements and catalogues printed to sell International Stock Food Company items. Dan Patch became a household name, as it could be found on everything from washing machines to tins of tobacco to watch fobs. Today, those pieces of history are collectibles, many of which adorn the Razor's Edge Barbershop in downtown Savage, which is owned by the president of the Dan Patch Historical Society, Jens Bohn. That building, the old Garvey's General Store, was the first store in Hamilton.

As the world grew to adore Dan Patch, the Hamilton depot agent found himself processing a large number of deliveries to Savage's horse farm. He commented that it would be easier if the place were called Savage. The depot's name was changed on March 26, 1904, and the city council officially adopted the name in 1919.

It was under Savage's ownership that Dan Patch excelled, setting records and charming crowds all over the country. He set a world record in 1906 at the Minnesota State Fair, pacing the mile in 1:55. Three years later, Dan retired to the farm in Savage. Legend has it that Savage died 32 hours after his beloved Dan Patch in 1916. Savage's death was said to be untimely, caused by a broken heart from the death of his beloved Dan.

While Savage owes much of its notoriety to its namesake and his famous racehorse, there are other pieces of the city woven into the history of the state, as well as the nation.

One of those occurred in 1923, when a little-known aviator crashed in a swampy area in town. His plane was forced down during a thunderstorm and landed so hard that he cracked its propeller. That 21-year-old pilot was Charles Lindbergh, who gained worldwide notoriety four years later for his nonstop solo flight on *The Spirit of St. Louis* from New York to Paris.

After his unscheduled stop in Savage, the uninjured Lindbergh cut himself free from his plane. By the time townspeople arrived, word had spread that the pilot was dead, so they were pleasantly surprised to find him alive and well. With the help of the townspeople, Lindbergh pulled the plane onto solid ground, but the broken propeller kept him from going much farther. For two or three days, Lindbergh remained in the village of Savage as he waited for a replacement propeller to arrive from his hometown of Little Falls. He stayed in the Savage Depot and was kept company by depot agent and mayor Charles F. McCarthy.

Today, that broken propeller is on display at the Lindbergh Historic Site and Museum in Little Falls, Minnesota.

The city of Savage was also an important part of the nation's success in World War II. In 1941, the city became home to the Military Intelligence Service Language School, whose purpose was to improve the foreign language skills of Japanese-American soldiers and to train them to be an important part of military intelligence efforts. Although it was first located at the Presidio in San Francisco, a new location had to be found after Pearl Harbor was bombed and Japanese Americans were evacuated from the West Coast. Savage was selected after a nationwide survey found Minnesota to have the best record of racial amity.

The selected site was on 132 acres located south of what is today Highway 13, near Xenwood Avenue. Camp Savage's first classes began on June 1, 1942, with a total of 200 soldiers. Within two years, the school grew to have 52 academic sections, 27 civilian and 65 enlisted instructors, and 1,100 students. Today, the camp's location is marked with a historical marker.

Also during World War II, thousands of workers built ships in Savage and launched them into the Minnesota River. Cargill Inc. built 23 ships for the US Navy, starting in 1942. The military became interested in Cargill after seeing the company's success at building ships and barges used to haul grain. The first ship to be built in Savage, the USS *Agawam*, was launched on May 6, 1943. During peak production times, the shipyard employed approximately 3,500 people.

After the war ended, Port Cargill became involved in shipping grain and other commodities. Today, hundreds of trucks stop at the ports on a daily basis, unloading corn, wheat, and soybeans grown in Minnesota fields, to be distributed throughout the world. Approximately eight percent of the nation's grain is shipped from Savage's ports.

In addition to shipbuilding and intelligence training, businesses in the community made other contributions to World War II. The Savage Tool Company manufactured machine tools and precision gauges expressly for the war. The company was eventually renamed Continental Machines and still operates at its original location.

In 1953, community service group leaders decided it was time to celebrate the city's heritage with Dan Patch Days. Buttons were sold to raise money to run the festival, beauty queens were selected, and parades, horse races, and rodeos provided the main entertainment. Marion Willis Savage's youngest son, Harold, often visited during these times, acting as part of the community celebration.

During this time, the town of Savage remained a one-square-mile area along the Minnesota River and Highway 13. In 1969, the town consolidated with Glendale Township to form the current 17-square-mile city of Savage.

Today, Dan Patch's name can be found on many businesses, the football stadium at Prior Lake High School, and one liquor store. There is no statue of Dan Patch or Savage, nor is there a historical marker in the city indicating where the International Stock Food Farms once stood, because it is on private land owned by Cargill. But there is a brick sculpture—or frieze—on one of the exterior walls of Savage City Hall depicting Dan Patch setting the world record at the Minnesota State Fair.

Other indicators in the town highlight the city's heritage. The weekly newspaper's name, the *Savage Pacer*, pays tribute to the city's horse racing history. At city hall, the city council chamber's design replicates the octagonal hub of the International Stock Food Farm— eight sides topped with an ornamental dome, which is illuminated at night. And at the city's library, the Heritage Room is a treasure trove of information about Dan Patch, Marion Willis Savage, and other historical aspects of the city.

One

HAMILTON, GLENDALE, SAVAGE

Very early on, French fur traders came to the Larpenteur Fur Company of St. Paul on the Credit River. By 1852, a small trading post was also established at the mouth of the Credit River, where it empties into the Minnesota River. Hamilton Landing was built on the banks of the river and became a place where many Scottish and Irish settlers got off steamboats.

Settlers with last names like Kearney, Nixon, Fish, Dorman, Woodruff, and Byrne dot local history books, but it is not clear who named the town Hamilton or why. Some family researchers have determined that it might have been John Kearney or William Byrne and that both men had family ties to Hamilton, Ontario.

As more people arrived in Hamilton, the tiny village grew. Shops and homesteads were built, and farming and trading were the primary industries. Plats show that Hamilton encompassed one square mile along the Minnesota River, whereas Glendale Township stretched south and was dominated by farms. Hamilton was established as a town on November 20, 1857, and was incorporated on August 31, 1892.

The first post office, Hamilton Station, was renamed Glendale Post Office in October 1894. In 1904, the depot agent, who processed a large number of deliveries to Marion Willis Savage's horse farm, hinted that it would be easier if the place were called Savage. The depot's name was changed on March 26, 1904. The town officially adopted the name in 1919 after city council approval. Savage and Glendale Township merged in 1969.

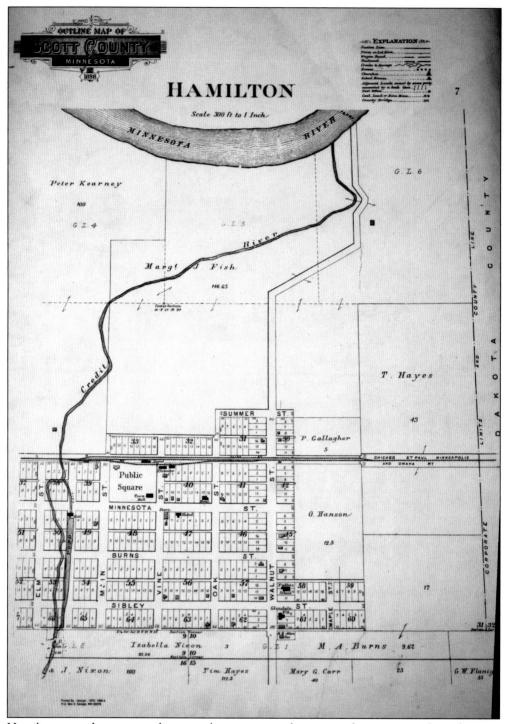

Hamilton started out as a trading post, but as more and more people came to settle in the area, the town grew. This map shows what the town looked like in 1898.

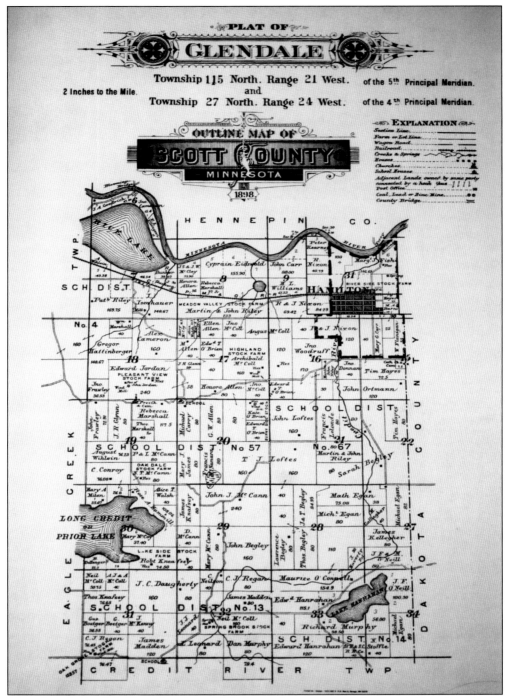

This plat of Glendale Township from 1898 shows the entire township, with Hamilton in the upper-right corner. Today, except for the area where "Long Credit or Prior Lake" is shown, this map shows the boundaries of the city of Savage.

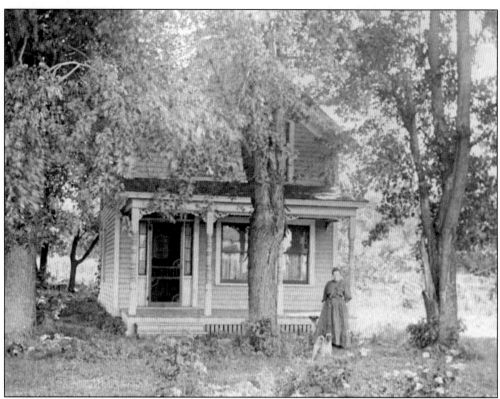

Some of the first homes in Hamilton included the Quinn home (above), built in 1870, and the Duffy home (below), built in 1915.

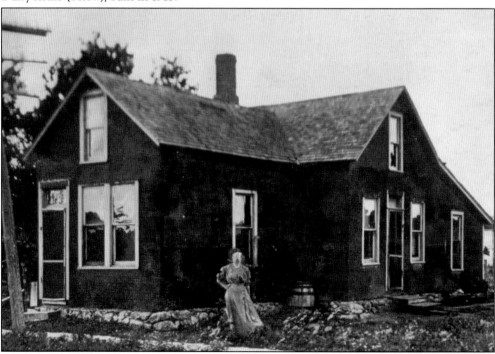

The first white child born in Hamilton, Margaret Nixon, was born on September 16, 1854. She was the daughter of David and Isabella Nixon and married Archie McColl. She passed away on April 6, 1951.

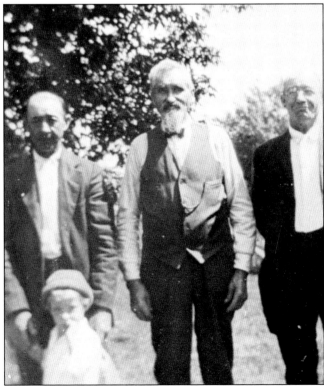

The Kearney family name is well known in Savage, as members of the family were some of the first to settle in Hamilton. Here, Peter Kearney (center) is flanked by his sons George and Eli Kearney in the summer of 1927. The child in front is Eli's daughter, Catherine Loraine Kearney.

13

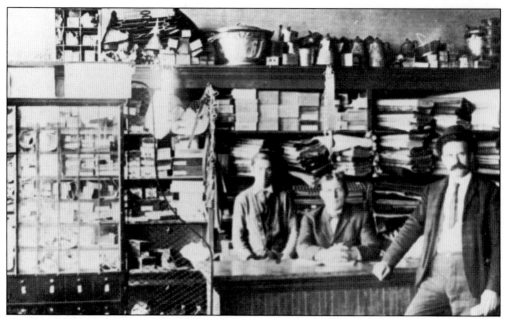

Garvey's Store had plenty of goods stocked on the shelves. The village post office is to the left. Pictured in this 1920s photograph are, from left to right, George Allen Sr., Ed Garvey, and Jim Heinz.

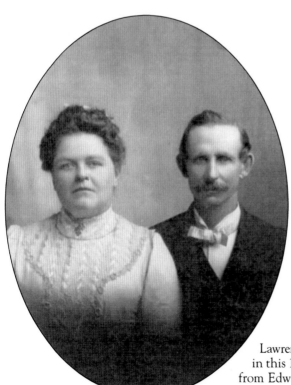

Lawrence Begley and Mary Hayes Begley (shown in this 1890s portrait) purchased Garvey's Store from Edward Garvey, who operated it in Savage from 1901 to 1939.

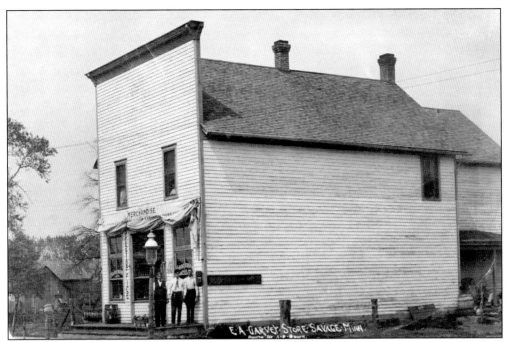

Garvey's Store was the first in Savage and served both as post office and general store. The building was moved to Savage from Burnsville, where it had been known as the Berrisford Store. The building is still located in Savage at the corner of Ottawa Avenue and 124th Street, housing the Razor's Edge Barber Shop and Beauty Salon. This 1903 photograph features, from left to right, Ed Garvey, George Coakley, and Charles Kline.

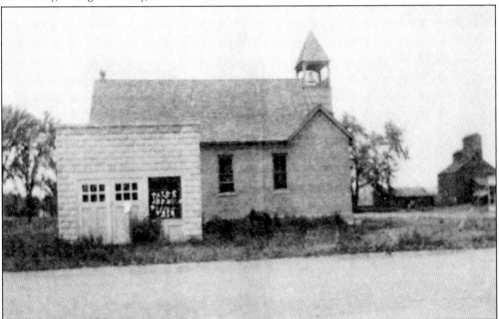

The city hall, fire department, and jail were all located in this one building on the town square, on present-day 123rd Street between Ottawa and Princeton Avenues. The words in the window read, "Taxes are high enough already. Vote for . . ."

This building was known by several names in the early 1900s: the Campbell House, McDonnell's Hotel, and Green Hotel. It was originally called The Boarding House, but it did not serve the public—only employees of the International Stock Food Farm. In her essay, "Savage in the Early 1900s," Mabel Magee McMahan offers some insight about what life was like at the boarding house. "Soon after the turn of the century, M.W. Savage advertised for someone to serve three meals a day, every day, to his thirty or more barn employees in a large house located across the road from the barn." Catherine Campbell answered the advertisement and did most of the cooking, while her daughters worked as waitresses. McMahon continues, "The Boarding House was a lively place, always full of activity. Young people gathered there evenings to join the barn employees in the fun. Many pranks were played, and there was much laughter."

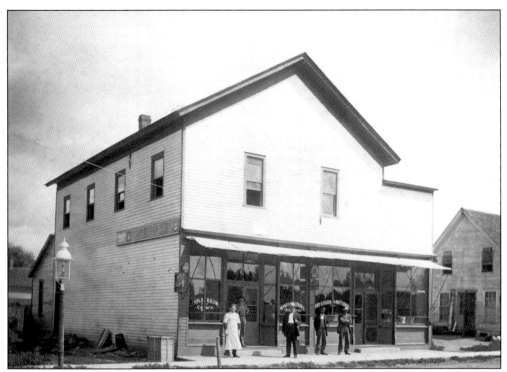

Riley's Store, pictured here around 1903, was run by the Riley family. It had a general store on the first floor, a dance hall on the second floor, and sold ice out of an icehouse in the backyard. At one time, the store also housed the village post office. It was located on the corner of what is now Ottawa Avenue and 123rd Street. The building was torn down by the city in the 1990s to make way for a mixed-used building with retail spaces and apartments. The historical roots of the city can be found in the new building's name: The Hamilton.

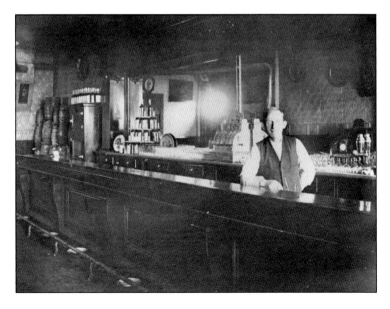

Martin Riley is pictured behind the bar at Riley's Store, which was a general store and post office on the first floor and a bar room, pool hall, and dance hall on the top floor.

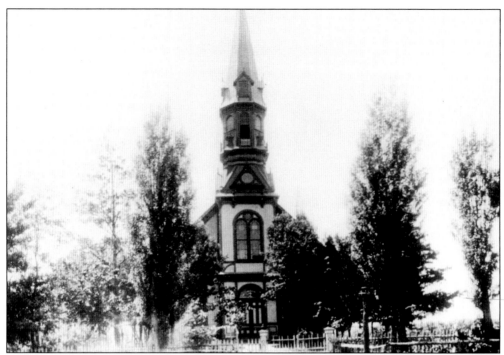

St. John the Baptist Catholic Church has deep roots in both Savage and Burnsville. The first Mass was offered by Father Augustine Ravoux in 1853. The original log church was built a year later in Byrnesville (now Burnsville) for a congregation of 10 families. Twelve years later, in 1866, the first framed church was built near the corner of what is now Williams Drive and Judicial Road. That building was burned to the ground by fire in 1883, rebuilt in 1885, and destroyed again by fire in 1902.

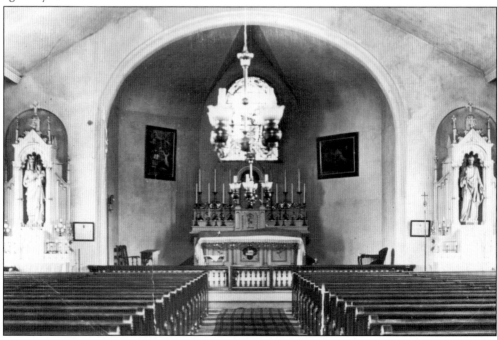

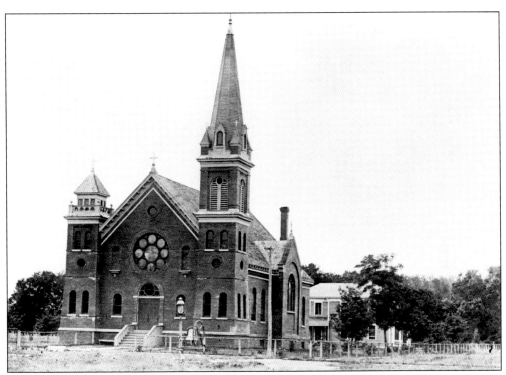

After the third fire, in 1902, the bishop decided that a new church should be erected in Hamilton, where most of the growth was occurring at the time. In 1903, a new worship center was built on present-day West 125th Street, costing $12,000. The large brick building continued to serve the community until 1986, when it was torn down to make way for the current church.

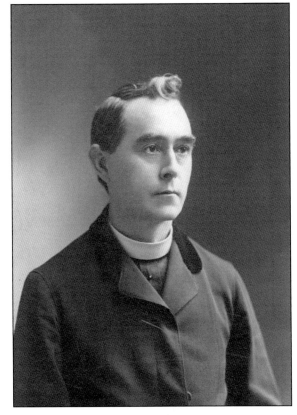

Father William Rhatigan was the sixth pastor to minister at St. John the Baptist Church. He served from 1896 to 1903.

This is the 1896 citizenship document for Michael Allen, one of the first settlers in Hamilton. The Allen family has a long history in Savage.

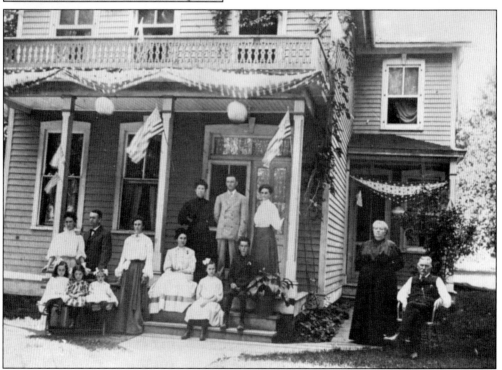

This photograph, likely taken around 1900, shows Michael Allen and his wife, Susan, on the right. The other family members on the porch are unidentified. The home appears to be decorated for the Fourth of July. Over the years, many members of the Allen family started businesses in the community. Allen's Garage started out fixing cars and eventually sold Dodge vehicles. Allen's Station, Allen's Towing, and Allen's Ambulance were also family businesses.

From left to right, Tom Duffy, Martin Riley, and Pat and Mike Walsh saddle up in this undated photograph.

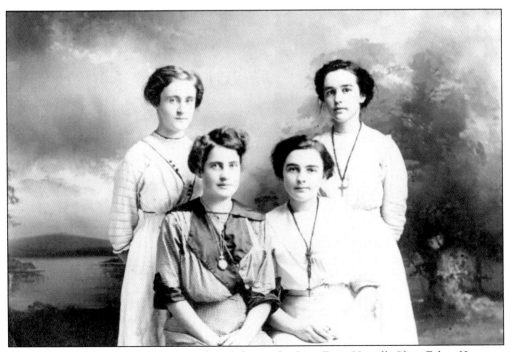

This quartet of young ladies features, from left to right, Jane Egan Hamill, Clara Fahey Kearney, Anna Gallagher Simpkins, and Marie Gallagher McDonald.

Martin Riley signed this oath to serve as Savage's postmaster in 1928. The first post office was called Hamilton Station, and Levi M. Williams was postmaster. Williams owned a farm that stretched from the Savage-Burnsville border to County Road 5 in Burnsville. Williams Drive is named after the family. Hamilton Station was established on June 12, 1866, and remained as such until October 29, 1894, when it was renamed Glendale. It became the Savage post office in 1904.

Charles Kline, Hamilton's first mail carrier, is pictured in front of Riley's Store on May 3, 1906.

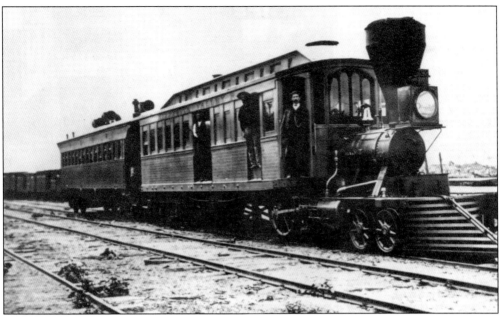

The Shakopee, a combination steam engine and passenger car, was transported by steamboat to Credit River Landing, arriving on November 2, 1865. It was the first steam locomotive in the state, placed into service on the line between Shakopee, Hamilton, and Mendota.

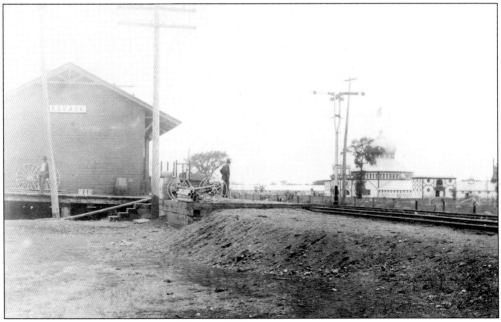

By 1910, the International Stock Food Farm had increased the pace of Hamilton. The railroad depot, in the foreground, was built in 1880 by the Chicago, Minneapolis & Omaha Railroad. The first railroad in Hamilton—the Minnesota Valley Railroad Company—changed its name in 1870 to the St. Paul and Sioux City Railroad. In 1904, the same year the name of the village was changed to Savage, the railroad changed its name again, to the Chicago Northwestern Railroad.

The Savage depot was located between the Minnesota River and the north side of what is now Highway 13. Depot agents included Peter Dempsey (pictured here, 1905–1917), Hugo Bromarder (1917–1921), Charles F. McCarthy (1921–1931), unknown (1931–1952), and Charles Oster (1952–1971).

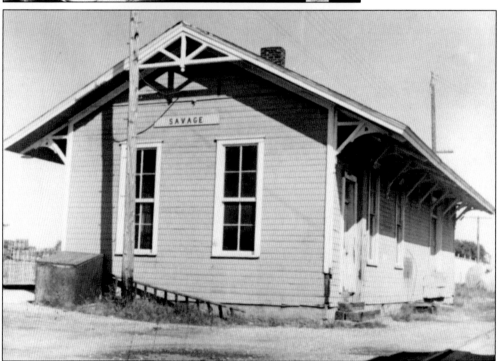

The Savage depot was closed in 1970 when a new depot was built between Shakopee and Savage to serve both cities. When depots are closed, they are typically sold or demolished, but the board of directors of the historical village, Murphy's Landing, purchased the Savage depot and moved it to their site in 1973. In 2004, Murphy's Landing determined it no longer needed the building and the next year the Dan Patch Historical Society began a fundraising campaign, "Bring the Depot Home." The depot arrived home in 2006 and was restored and reopened in 2007. It is now home to a restaurant, The Depot, across the highway from its original location. The block where it now sits is the original public square from the 1898 plat of Hamilton.

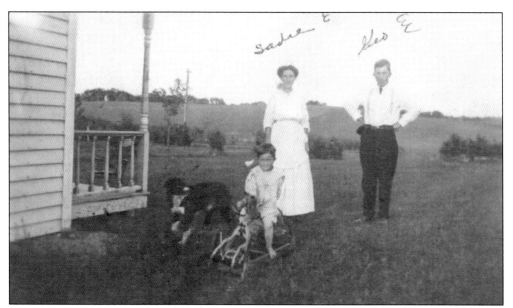

George and Sadie Egan's son Mark plays outside their home in Glendale in 1913. The home, near the entrance of present-day Hidden Valley Park, still sits there today. (Courtesy of Ray Egan.)

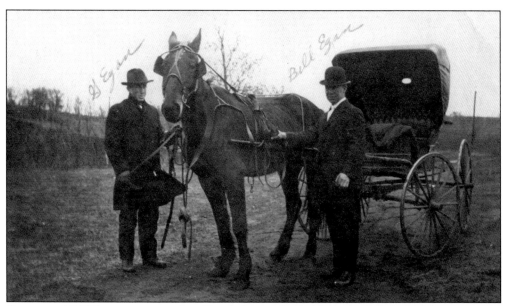

George and Bill Egan are pictured on Egan's farm in 1910. (Courtesy of Ray Egan.)

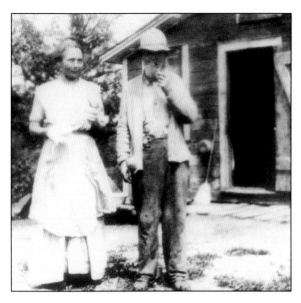

Matthew Egan smokes a pipe alongside his wife, Jane Donnelly Egan, in this undated photograph. Matthew's father, Michael Egan Sr., emigrated in 1847 from County Mayo, Ireland, and had five children: Maria, Patrick, Michael Jr., Matthew, and Catherine Egan. The family originally settled in West Virginia but came to Stillwater, Minnesota, in 1857. In 1873, Matthew bought a farm in Savage next to his brother Michael Jr. Matthew married his first wife, Jane Donnelly, in 1877. After she died, he married Alice (Allen) Gaffney in 1889. She had one son from a previous marriage. Matthew and Alice had six children: Michael, James Joseph, Mathias, Marie, Patrick, and John.

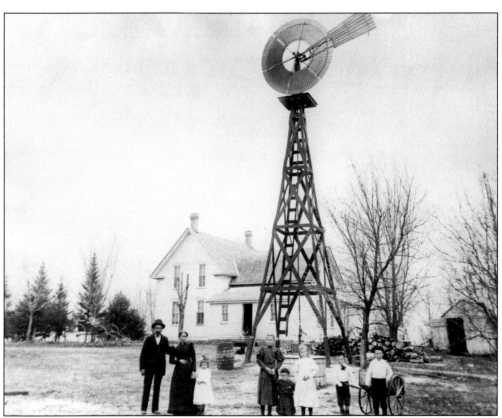

Many settlers made Glendale their home, including Michael Egan Jr. and his family. This 1896 photograph shows Michael Egan Jr., his wife, Mary Jane Garvey Egan, and their children, Jane, Mary, William, Margaret, Edward "Ward," and George. The farm was located in what is now a busy retail area at the corner of Egan Drive and Joppa Avenue.

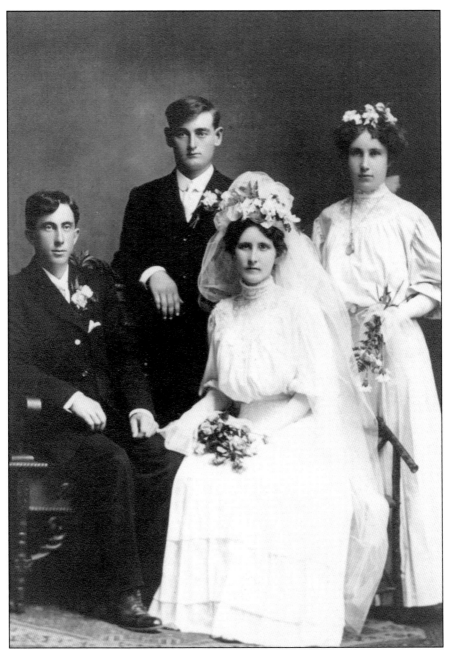

George Egan and Sadie Kennedy Egan pose at their wedding in 1908 alongside best man Martin Allen and bridesmaid Margaret Egan. Rev. Father John Deere led the ceremony at St. Peter's Church in Credit River. A newspaper account describes the occasion: "The bride was attired in white banzai silk trimmed elaborately with all-over lace. Her veil was fastened with a wreath of lilies-of-the-valley and she carried brides' roses. Miss Maggie Egan, her bridesmaid, was gowned in pink silk and her flowers were pink carnations. Martin Allen of Savage acted as best man and Patrick and Will Kennedy were ushers. The ceremony over, the bridal party, attended by relatives and friends, repaired to the Kennedy home where a pavilion for dancing had been erected and a most enjoyable time was spent during the day and evening." (Courtesy of Ray Egan.)

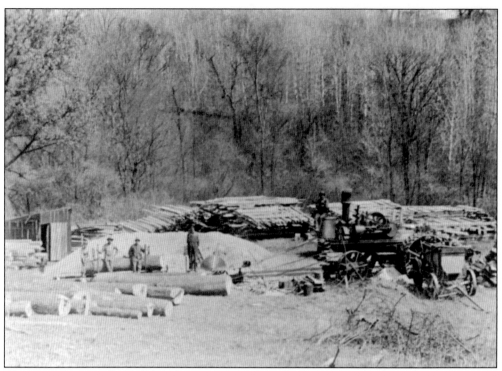

The Savage Saw Mill was located just south of the village in the early 1900s. It was owned by John Woodruff and located on the Credit River, adjacent to Woodruff's Hill and south of what is now County Road 16.

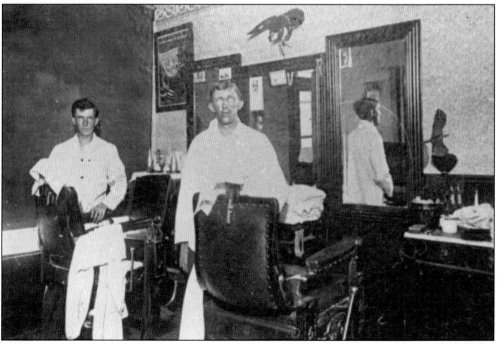

Ed Hanson and Jess LaVelle manned the chairs at Ed Hanson's Barber Shop in the early 1900s.

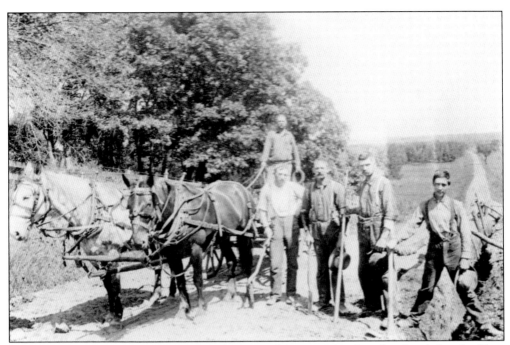

John Nixon, Mort Riley, Jim O'Brien, Frank Reis, and George Schaefler take a break from building Boylan's Hill Road in 1901. The road was one of two from the old territorial trail—the St. Paul-Shakopee Road—that provided access into Hamilton from Glendale. It is commonly believed that the road was named after an early settler. Years later, it was renamed Hayes Hill Road, after Tom Hayes, who owned a farm at the top of the hill. The road is now Lynn Avenue.

The Foley family of Burnsville poses for a family photograph sometime before 1900. Patrick and Mary Foley arrived in Burnsville in 1850 and settled on a farm near the Burnsville/Savage border on present-day County Road 42. The Foley family joined St. John the Baptist Catholic Church when the church was first established in Burnsville. It later moved to Savage after a fire. The roots of many pioneer families run deep in both cities.

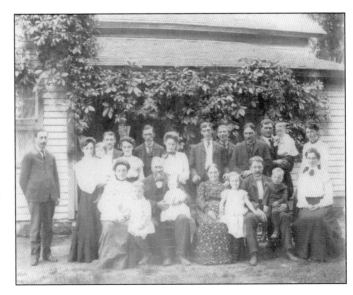

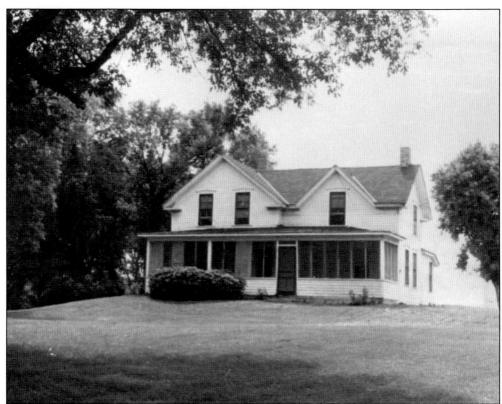

Irish immigrants John McCann and Mary McAndrews McCann were married in Illinois in 1853. They moved to this homestead in Glendale in 1854, when it was still considered rural Scott County, and settled a farm. They raised nine children on the farm: Ann, Mary, John, Bridget, Catherine, Patrick, Dennis, Rose, and Margaret. John McCann died on his farm in Glendale in 1874, but Mary McAndrews McCann far outlived her husband, passing away in 1926.

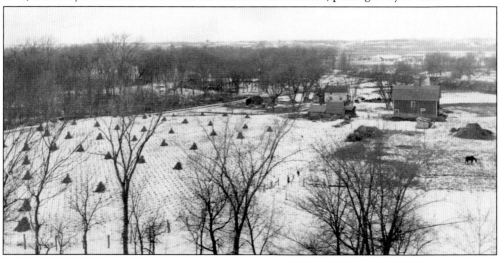

John McQuiston's homestead was located along the Credit River on what is now Quentin Avenue. This photograph, taken in the early 1900s, looks north from the hill on Highway 13, which is now County Road 16.

Two

MR. SAVAGE COMES TO HAMILTON

Marion Willis Savage was a successful businessman by 1902, the year he purchased 400 acres in Hamilton and chose the river town as the place to build his International Stock Food Farm. In December of that same year, he purchased a promising pacer named Dan Patch for the unheard-of sum of $60,000.

Savage's love of horses began in Iowa, where he grew up the son of a country doctor. He was a farmer until flooding ruined his crops. When he was clerking in a West Liberty, Iowa, drug store, he observed the local farmers' stock food and drug purchases and decided to manufacture the supplies himself. He formed a partnership with a friend who soon made off with all of their funds, leaving the 27-year-old Savage nearly penniless.

In 1886, Savage and his wife, Marietta Bean, moved to Minnesota to start anew. Minneapolis had become the center of the expanding dairy, farming, and livestock industries. He started in a small stock food manufacturing plant and used the local scientists to develop his own brand. In a few years, he was successful enough to purchase the huge Exposition Building on the river in Minneapolis.

There Savage centered his International Stock Food company, which eventually grew to have affiliated plants in Toronto, Memphis, and overseas in Scotland, Ireland, England, France, Germany, and even Russia. He was famous for his ability to come up with original ideas and carry them out. He invented the slogan, "Three Feeds for One Cent" to capture the attention of farmers, and it became a household phrase. Savage was also a great promoter, featuring his wares in catalogues and offering coupons—two largely untapped sales strategies.

As his fortunes grew, Savage turned his attention to satisfying his dream to breed champion horses. He built extensive stables and two racetracks on his estate and began buying racehorses.

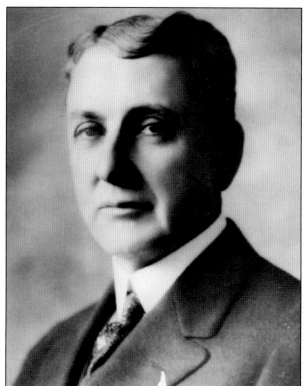

This photograph of Marion Willis (M.W.) Savage was taken in 1915. During his lifetime, his business holdings included International Stock Foods, International 1:55 Stock Food Company, International Sugar Company, Ta-wa-nee Springs, Quick Clean Soap Company, the Dan Patch Electric Line, International 1:55 Stock Food Farm, M.W. Savage Art Company, and Antler's Park. He is best known for his original ideas and ability to carry them out. He also used his horse Dan Patch as a celebrity to promote many of his businesses, a concept that had never been done before.

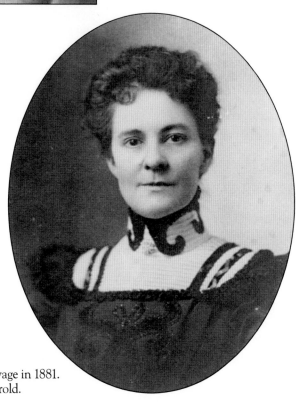

Marietta Bean Savage married M.W. Savage in 1881. They had two sons, Erle (E.B.) and Harold.

Erle (E.B.) Savage was born in 1883 and this photograph was taken in 1905, two years after he went to Toronto to head one of his father's new entities, the International Stock Food Co. Ltd. By 1910, he was splitting his time between Minneapolis and Toronto. He was considered his father's right-hand man and helped organize all of his father's enterprises into one firm, the M.W. Savage Factories, in 1911.

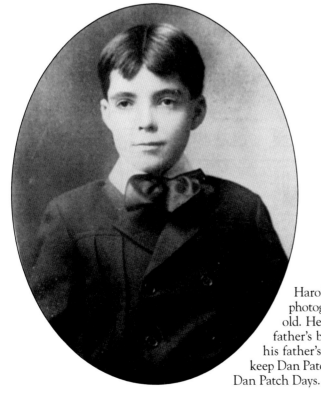

Harold Savage was born in 1894 and this photograph was taken when he was 10 years old. He was a boy during the time that his father's businesses were growing. He shared his father's love of horses and worked hard to keep Dan Patch's memory alive by participating in Dan Patch Days.

One of Savage's many innovative ideas, his "Three Feeds for One Cent" slogan, captured the attention of farmers and eventually became a well-known phrase.

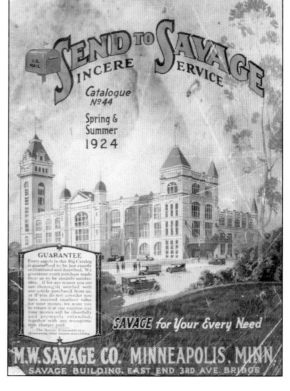

This "Send to Savage" catalogue cover from 1924 shows off the marketing skills that helped Savage sell not only his line of livestock food and supplements, but also a wide variety of other goods. His promotional skills and new ideas, like offering catalogues and coupons, made him a successful businessman.

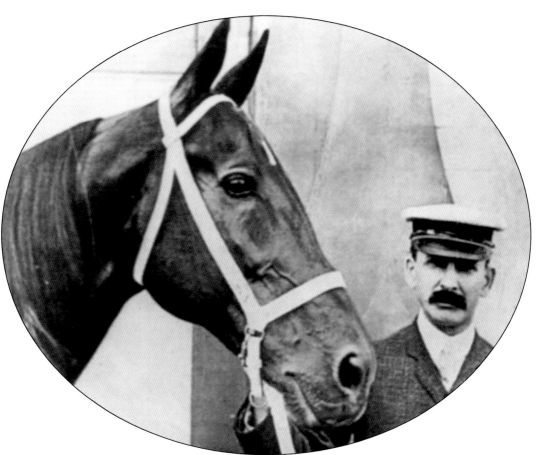

This photograph of M.W. Savage and Dan Patch, taken between 1905 and 1907, is probably the most recognized image of the Minneapolis entrepreneur and his racehorse. Today, a likeness of the image adorns a peak of the Dan Patch Liquor Store in downtown. It is also found on many collectible items because Savage used Dan Patch's celebrity status to promote products sold by his companies. The bond of affection between the horse and his owner was great. Dan Patch died on July 11, 1916, when he was 20 years old. Savage died 32 hours later at the age of 57. Savage was hospitalized for minor surgery, but upon being told of Dan's death, his own condition worsened. Legend has it that Savage's untimely death was caused by a broken heart.

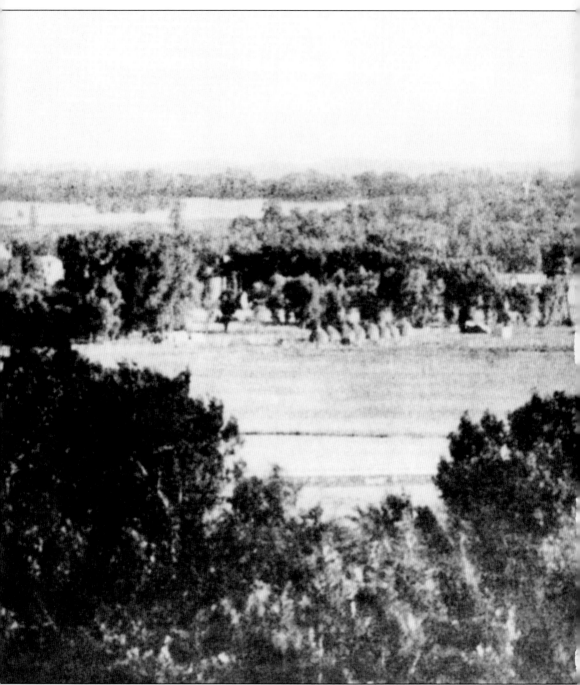

The International Stock Food Farm was often referred to as the "Taj Mahal" because of its opulence and size. It had a big rotunda in the middle, with wings that came out like spokes on a wheel. The rotunda was octagonal—100 feet long with a 90-foot diameter. It was topped with an Oriental-inspired dome, which people described as an onion or an upside-down turnip. But it had a purpose—the dome contained a huge water tank for the horses and for the other water needs on the farm. The floor of the rotunda was tanbark and there was a large glass display case that

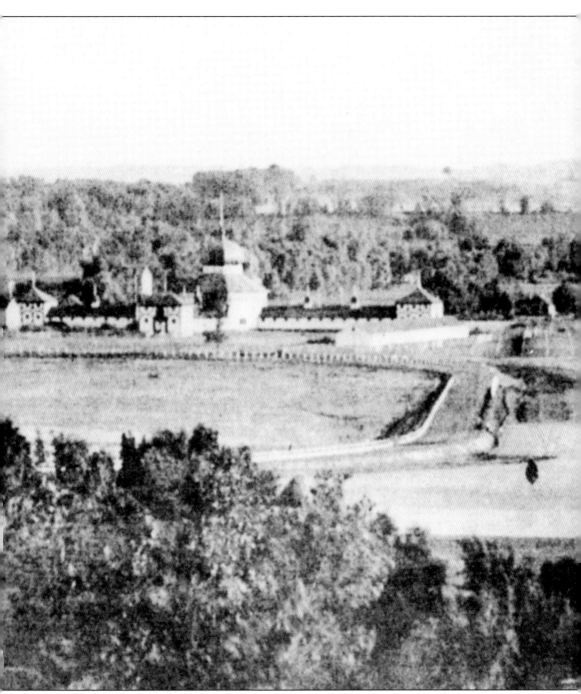

included International Stock Food Company products. Each of the five wings of the barn was 160 feet long and contained stalls for 130 horses. At the end of one of the wings was Dan Patch's stall, which measured 20 feet by 20 feet. It had window shades and monogrammed woolen blankets. The barn had a hot water heating system, ventilation, and electric lights. The main stable had living quarters for 60 employees. The barn cost $50,000 to build and could easily be seen from the railroad, the Minnesota River, and the bluffs on the other side of the river.

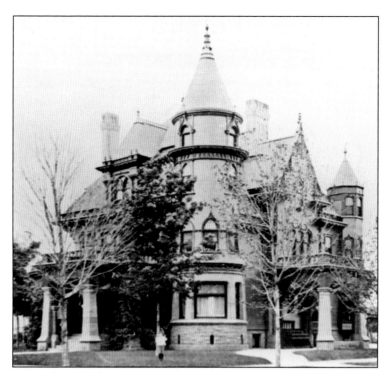

Savage's main residence was in Minneapolis, at Twenty-Sixth and Portland Avenues. In the wintertime, he would hook Dan Patch up on a sleigh and take him out for rides on the surrounding streets. The child pictured in front of the house is Harold Savage.

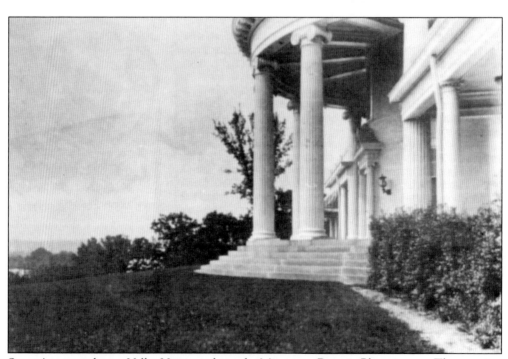

Savage's summer home, Valley View, sat above the Minnesota River in Bloomington. The mansion was 115 feet long and included a large main hall. On the riverside, a large porch provided Savage and his family and guests a view of what was happening on the farm in the valley below.

This 1904 photograph of Savage and his son Harold sitting on a bench at Valley View overlooking the International Stock Food Farm was often used to promote the farm in International Stock Food Farm catalogues and other publications.

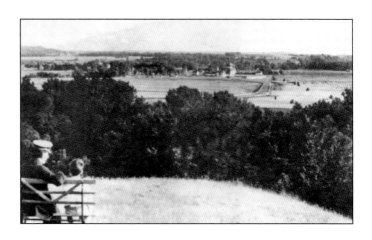

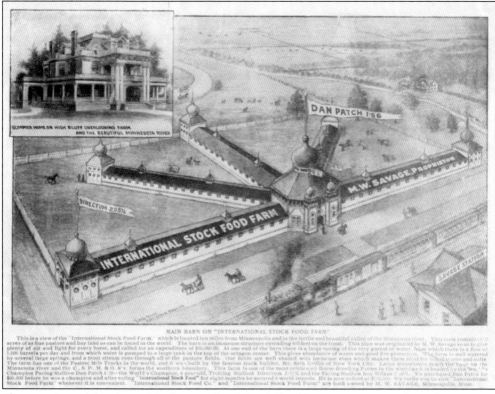

SUMMER HOME ON HIGH BLUFF OVERLOOKING FARM AND THE BEAUTIFUL MINNESOTA RIVER

DAN PATCH 1:56

DIRECTUM 2:05¼

INTERNATIONAL STOCK FOOD FARM

M.W. SAVAGE, PROPRIETOR

SAVAGE STATION

MAIN BARN ON "INTERNATIONAL STOCK FOOD FARM"

Photographs and drawings of the International Stock Food Farm were commonly used to promote the business. These drawings and photographs could be found in Savage's catalogues, in his "Colts and Race Prospects" booklet, and even inside the sheet music for the "Dan Patch Two-Step." This drawing also included the Valley View home in the top-left corner and was created by the M.W. Savage Art Company. Narratives that accompanied these drawings described the International Stock Food Company as "the largest medicate stock food factory in the world" with 500 employees. The factory was located on the east side of the Mississippi River overlooking St. Anthony Falls. The feed was sold with a "spot cash guarantee." At the end of one narrative about the factory, it states: "Largest stock food factory in the world. Capital Paid in $2,000,000.00."

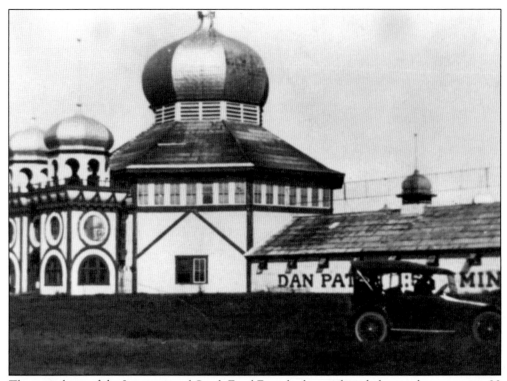

The main barn of the International Stock Food Farm had an eight-sided rotunda, measuring 90 feet in diameter. The dome was painted green, and its shape gave the stables an Oriental flavor. It was actually a water tank, fed by three nearby springs.

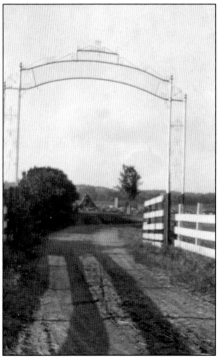

Here is the entrance gate on the road to the International Stock Food Farm. Between the barn and the river was a mile-long track that cost $18,000 to build. A few years later, a half-mile covered oval racetrack was built for $17,000 so that horses could be trained in any kind of weather. Today, the barn and outbuildings are no longer standing, but the outline of the track can still be seen from the air.

DAN PATCH STABLES

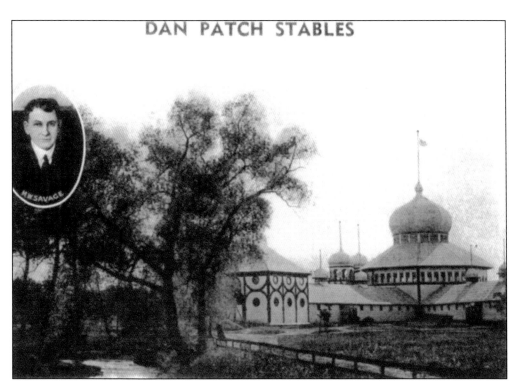

These postcards were produced to promote the International Stock Food Farm experience. In the postcard below, Little Patch, Dan's mascot, can be found in several of the photographs. He is sitting on the sulky seat (top middle) and standing on the track behind the handler (top right).

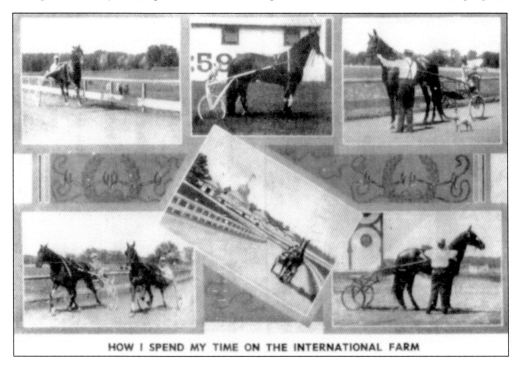

HOW I SPEND MY TIME ON THE INTERNATIONAL FARM

From left to right, Tom Kinesky, Jack Gaffney, Mike Hynes, and Jim Hurley worked on the International Stock Food Farm in the early 1900s.

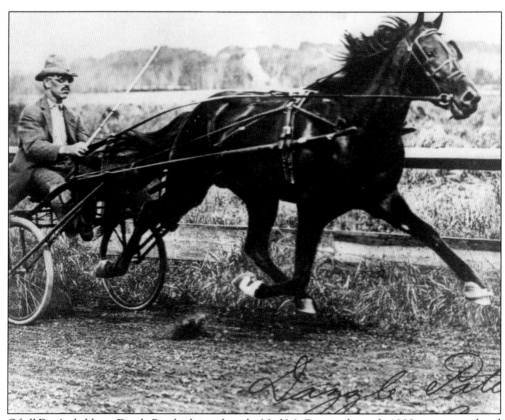

Of all Dan's children, Dazzle Patch, driven here by Ned McCarr in the early 1900s, was considered the most talented. He once paced a half-mile in 56.75 seconds. A long list of Dan's children ultimately raced 2:30 or better. Some of the other horses in the stable were Minor Heir, George Gano, Hedgewood Boy, and Lady Maud C.

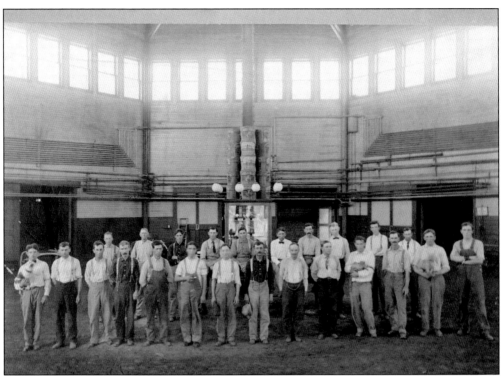

This 1903 photograph of the rotunda shows 24 employees at the International Stock Food Farm. Some of the workers pictured are John McQuiston, Mike Egan, George Small, Charlie Plummer, Hal Huth, Murray Anderson, and Charlie Ganney. The farm employed people from all the surrounding areas. There were stable crews—two caretakers for each champion and one for each of the younger horses—as well as blacksmiths, grooms, trainers, drivers, and stable hands. Little Patch, Dan's mascot, is being held by Mark McDonnell, second from right.

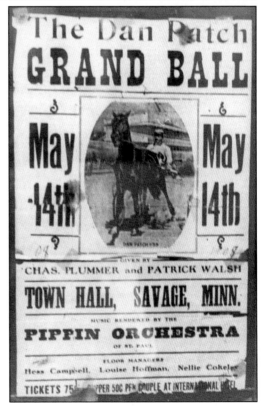

"The Dan Patch Grand Ball," featuring the Pippin Orchestra, was given by Charlie Plummer and Patrick Walsh at the Town Hall.

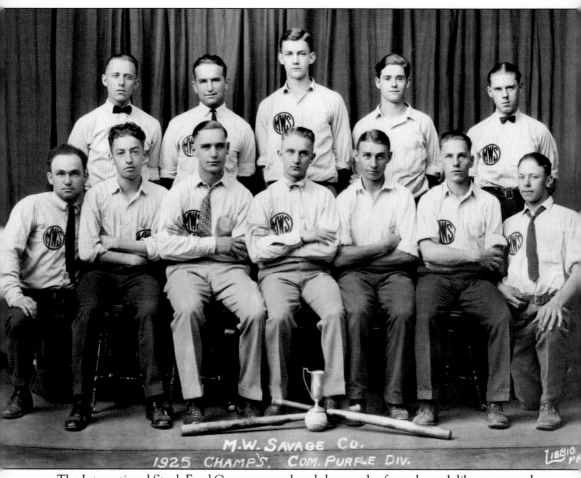

M.W. SAVAGE CO.
1925 CHAMP'S, COM, PURPLE DIV.

The International Stock Food Company employed thousands of people, and, like many modern companies, it sponsored a baseball team. Pictured here is the 1925 championship team. The team was originally organized in the early 1900s. After Dan Patch set the world record, "1:55" was included on the front of their uniforms. There were reportedly several teams, one associated with the company in Minneapolis and another with the farm in Savage. Unfortunately, none of the players on the team pictured here are identified.

Ta-wa-nee Springs was one of Savage's business ventures. It took water from one of the three springs that went through the International Stock Food Farm and used it to produce five different waters and soda pop.

One of the destinations of the Dan Patch Electric Railroad in 1910 was Antler's Park, an amusement resort in Lakeville. It was built by Savage on Lake Marion, which was named for him. A large existing structure was modified into a hall for weekend dances. A clubhouse, bathing beach, aerial swing, shoot-the-chutes, and a miniature railway were some of the attractions.

This is a reproduced cover of a 1916 "Colts and Racing Prospects" booklet that was produced to sell and promote the horses raised on the International Stock Food Farm.

One of Savage's business hallmarks was a promise to buyers, which appeared in publications for nearly everything he sold, including the horses bred on the International Stock Food Farm.

INTERNATIONAL 1:55 HORSE FARM

BUYING HORSES BY MAIL

I want you to fully understand that you can buy a horse or colt of me by mail just as safely and satisfactorily as if you came to the Farm. You are absolutely protected by my **personal guarantee** printed below. You surely know my business reputation (which I have built up with 26 years of fair dealing) and realize that any agreement I make with you **must** be made good.

I am ready to deal with you in exactly the same way that you would deal with your best friend. Practically all of my horse sales each year, are made to people who buy on my recommendation, without seeing the animals. My Mail Customers secure just as good selections as those who come to the Farm in person. The reason is simple. I know every detail about my horses, and I will give you the unvarnished facts about the one you are buying.

Just place yourself in my position for a moment, and you can readily see that I would be very short-sighted if I did not deal fairly with you. When I please one customer, I can sell him and his friends again and again. It is plain that I cannot afford to send out **one** horse not as represented, or have **one** dissatisfied customer in the whole country. Read the letters on page 48, and note what a few recent buyers have to say.

To me, a customer is a friend, and my interest in him only just begins **after** he has purchased one of my colts. You will find me always ready to give you any advice and help that will aid you in making a Big Success. Such results will be a great benefit to you and also to me, and this makes it mutual.

MY GUARANTEE TO YOU

Any Horse bought of The International 1:55 Horse Farm by mail, is not only Guaranteed **exactly as described** (or to be returned at once at my expense), but it also has back of it, World Champion Stallions and over $500,000 in World-Wide Advertising, that help make it worth a lot of Extra Money from any breeder's standpoint.

M. W. SAVAGE.

4

President M. W. Savage

M. W. SAVAGE, President of the Dan Patch Electric Railroad, is perhaps one of the best known advertising and individual business men in the world.

He is known best as the sole owner of the International Stock Food Company, the largest institution of its kind in the world; and as the owner of Dan Patch 1:55, the highest priced and fastest harness horse that ever lived in all the history of the world.

Through these two mediums and through his various other successful enterprises, it is safe to say that he is known to at least fifty millions (50,000,000) people, not only known, but favorably known as a dependable man who thoroughly believes in fair and square dealing. No safer, better man could stand at the head of any railroad or any other great enterprise, and you can be assured that your investment, no matter how small, will be protected equally with his own investment as his stock is just the same as we are offering to you.

President Savage is a man after the people's own heart, and as President of the Dan Patch Electric Railroad — the People's Railroad — he will prove a safe partner for all those who become stockholders with him.

HE BELIEVES IN THE PEOPLE

An inside page of the booklet designed to attract investors to the Dan Patch Electric Railroad included a message and promise from Savage. He described the railroad as the "people's railroad" and pledged to be a "safe partner for all those who become stockholders."

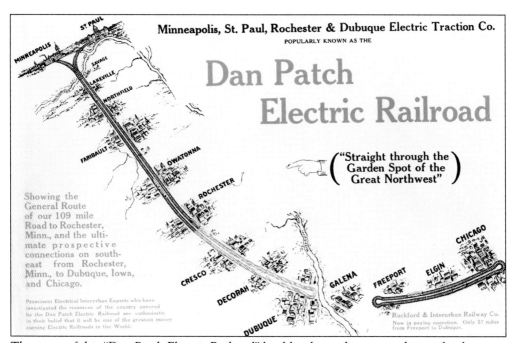

The cover of this "Dan Patch Electric Railroad" booklet shows the proposed route for the train.

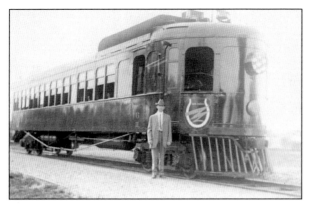

This is a locomotive from the Dan Patch Electric Railroad, which was formally known as the Minneapolis, St. Paul, Rochester & Dubuque Electric Traction Company. Incorporated in 1907, the train route was originally planned from Minneapolis to Rochester, with an eventual extension to Dubuque. But the route only extended as far as the town of Northfield, about 40 miles below the Twin Cities.

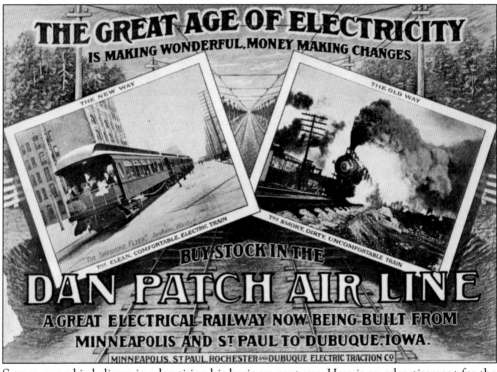

Savage was a big believer in advertising his business ventures. Here is an advertisement for the Dan Patch Electric Railroad, promoting the clean power of electric over a traditional steam engine. In 1918, two years after Savage's untimely death, the line went into receivership and was sold to the Minnesota, Northfield & Southern Railway. Later, the Soo Line Railroad took possession, and now, the old Dan Patch Line's path is within Canadian Pacific Railway jurisdiction. Despite the name, the line was never electrified.

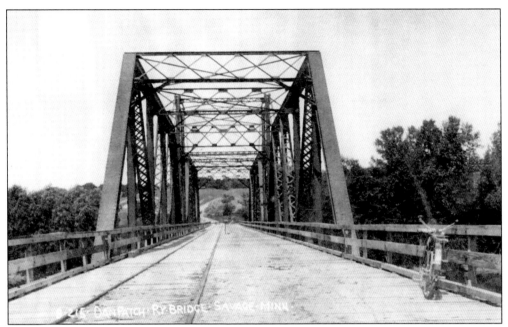

"Our Splendid Double Track $50,000 Steel Drawbridge" was built by Savage in the early 1900s to carry Dan Patch Railroad trains over the Minnesota River. At one time, the bridge was expanded to also carry cars, one lane at a time, as shown in this undated photograph. The bridge still stands today, but is no longer in operation. It was a center pivot swing bridge, swinging open to allow barge traffic to pass on the Minnesota River and swinging closed to allow trains on the tracks. When the bridge was used for cars and rails, it would close for motor vehicle traffic when a train needed the tracks, or if the bridge needed to be swung open for a barge on the river.

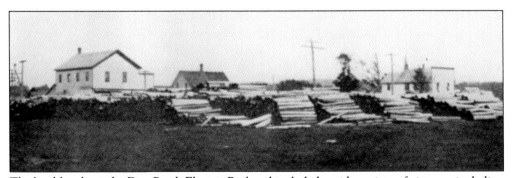

The booklet about the Dan Patch Electric Railroad included a wide variety of pictures, including this photograph of materials stacked and ready to be used. Note the downtown area of Savage in the background.

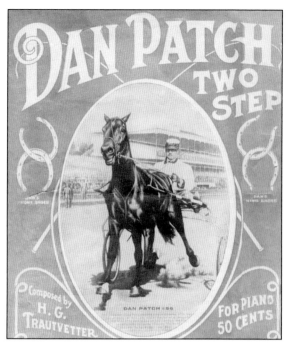

This is the cover of the "Dan Patch Two-Step," composed by H.G. Trautvetter, one of two songs written bearing the horse's name. The other was the "Dan Patch March."

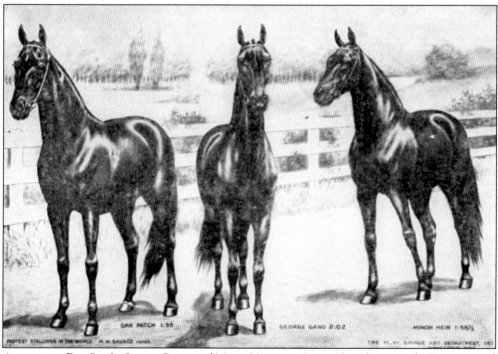

At one time, Dan Patch, George Gano, and Minor Heir were the top three horses at the International Stock Food Farm. The M.W. Savage Art Company produced artwork that was signed by the artist. Minor Heir achieved the most notable career after Dan Patch. His best time was 1:58.5. George Gano was one of a string of talented standardbreds purchased by Savage and brought to the farm as Dan Patch neared retirement. This artwork was probably commissioned sometime after 1908, the year Savage bought Minor Heir.

Three

THE GREAT DAN PATCH

Dan Patch is widely considered the greatest harness racing horse of all time. His most famous race was at the Minnesota State Fair in 1906. By that time, no one would race their horse against Dan, so he mainly raced in exhibitions and against the clock. Savage boasted that Dan would set a record at the fair. People packed the grandstand at the fair to see if it would happen. Dan Patch was 10 years old at the time, but did not disappoint the crowd, setting the record at 1:55 on September 8, 1906.

Three years later, Dan retired to the International Stock Food Farm, where people continued to visit to see the famous horse and the farm. What seals this story for many folks is the way Savage and Dan Patch bonded over the years and stayed that way until the end. As the story goes, the pair died within 32 hours of each other in 1916. Both appeared to rally from their illnesses, but suffered relapses. Dan died on July 11, 1916 and Savage, who was in the hospital at the time recovering from minor surgery, died unexpectedly the next day. "The shock and grief he experienced," reported the *St. Paul Pioneer Press-Dispatch*, "were almost unbearable."

Twin funerals to observe the last rites were held. Savage was laid to rest in Lakewood Cemetery and Dan Patch was buried in an unmarked grave on the banks of the Minnesota River in a secret location. His exact burial spot was only known by a few and has been passed to select others over the years.

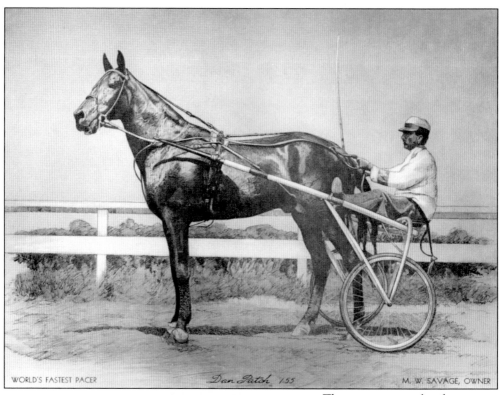

WORLD'S FASTEST PACER *Dan Patch* 1:55 M. W. SAVAGE, OWNER

There were many sketches commissioned depicting the great Dan Patch. This one has been reproduced many times and shows Dan ready for a race. Dan Patch won his first race in 1900 and never tasted defeat, losing only two heats in his career.

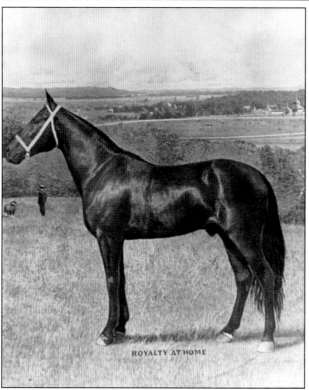

ROYALTY AT HOME

Images of Dan Patch were used in a variety of ways by Savage to promote his talented pacer. Here is a sketch with the words "Royalty at Home" along the bottom. It shows Dan on the grounds of the Valley View estate, and overlooks the farm on the other side of the river.

Once he set the world record of 1:55 for pacing a mile at the Minnesota State Fair in 1906, postcards with that declaration and a sketch of Dan finishing with the grandstands in the background were produced. This postcard is still in circulation and available from the Dan Patch Historical Society.

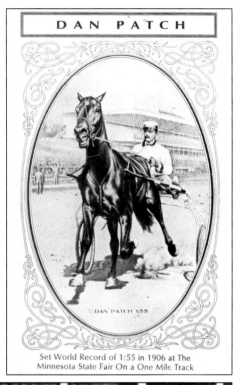

Set World Record of 1:55 in 1906 at The Minnesota State Fair On a One Mile Track

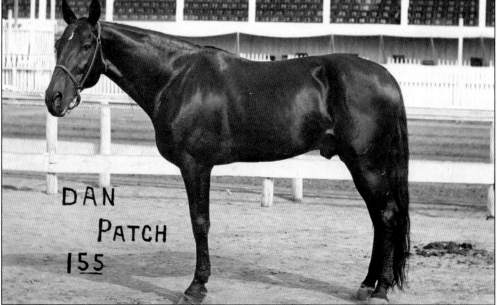

This vintage photograph of Dan Patch was reproduced on a postcard sometime after 1906, the year he set the 1:55 mark. Dan Patch was born on April 29, 1896, in Oxford, Indiana. His sire was Joe Patchen, and his dam was Zelica. He was named "Dan" after his first owner, Dan Messner, and "Patch" after his sire, Patchen. He was a pacer, which is a horse with a gait in which the legs on the same side move together. Drivers ride behind pacers in a sulky—a two-wheeled vehicle. Before Savage bought Dan Patch in 1903, he was owned by Dan Messner (1896–1901) and M.E. Sturgis (1901–1903).

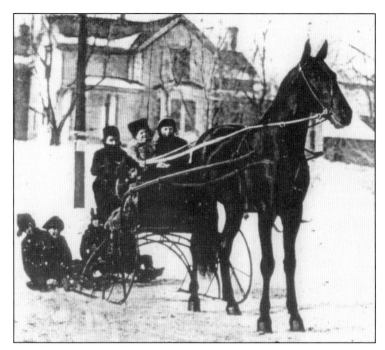

In this 1910 photograph, Dan is shown pulling a sleigh with a group of young boys near Savage's home on Portland Avenue in Minneapolis. Young Harold Savage is at the reins as the neighborhood boys play together on a winter day in Minnesota.

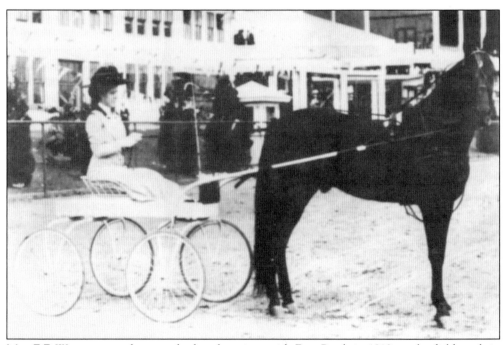

Mrs. E.F. Winegar was photographed at the reigns with Dan Patch in 1910 on the field track in Hot Springs, Arkansas.

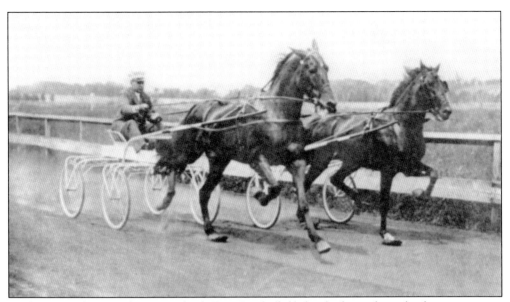

In this 1905 photograph, Savage leads Dan Patch (left), hitched to a four-wheel racing wagon, and Dazzle Patch, hitched to a sulky.

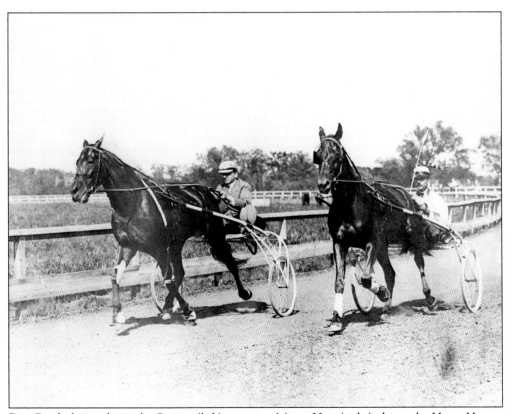

Dan Patch, being driven by Savage (left), is racing Minor Heir (right), driven by Harry Hersey. The photograph was likely taken between 1908 and 1909.

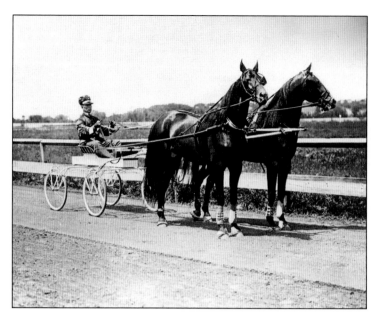

Driver and trainer Ned McCarr is shown at the reins of two of Savage's champions on the International Stock Food Farm around 1909. George Gano is on the rail and Minor Heir is on the outside. Although Dan Patch was the top horse at the farm, other champions were being groomed to take his place.

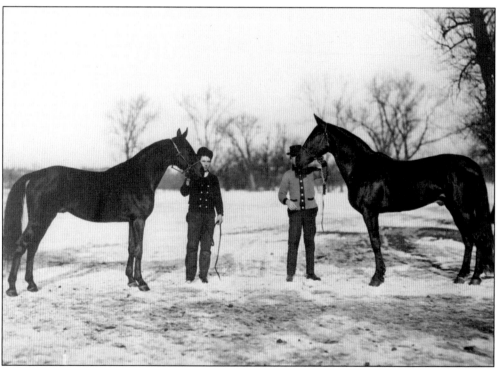

This photograph, "First Time the Two Champions Meet," shows Minor Heir (left) and Dan Patch (right). In the fall of 1909, Dan came out of retirement for one last season and was paired in a series of match races against the rising star of the International Stock Food Farm stables, Minor Heir. At the first event, in Grand Forks, North Dakota, Minor Heir became the first and only horse to best Dan in head-to-head competition. In the other four races, Dan Patch bested Minor Heir repeatedly.

As Dan Patch inched closer and closer to setting a world record, Savage promoted him more and more. This advertisement was designed to draw people to the Minnesota State Fair in 1906, where Savage promised that Dan would set a world record. Savage was referred to as the P.T. Barnum of his time because of his knack for self-promotion. He promoted all of Dan Patch's races heavily, but never raced Dan on Sundays, because "Dan was a Methodist." The horse was actually a member of Wesley United Methodist Church in Minneapolis, as was Savage.

CAN DAN PATCH
BREAK THE WORLD RECORD?
SATURDAY P. M.
(3 TO 4 O'CLOCK)
AT MINNESOTA STATE FAIR

SPECIAL NOTICE.

The track will be better, Dan will be faster, and Mr. Savage promises that every possible effort will be made to break the world's record of 1:55¼ on Saturday afternoon. Dan will pace three miles and his fastest mile will be about 4 o'clock. If you want to see a thrilling sight and witness a wonderful performance be sure and visit the great Minnesota State Fair on Saturday.

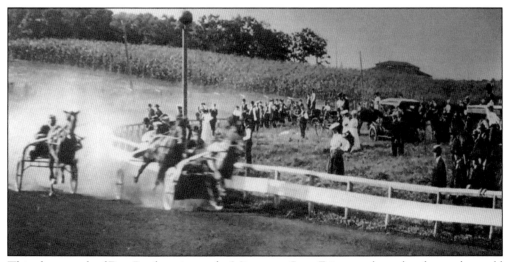

This photograph of Dan Patch racing at the Minnesota State Fair was taken when he set the world record at 1:55 on September 8, 1906. Dan raced at the fair two times that year—on opening day when his time was 1:56.5, and five days later when he set the world record of 1:55.

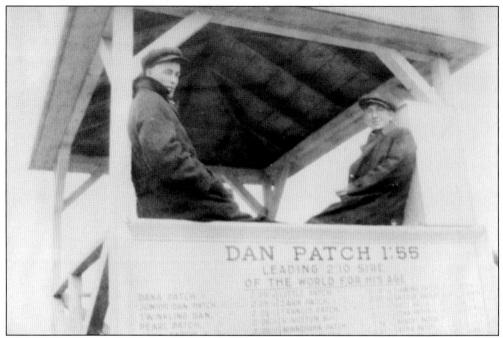

Henry McDonald and an unidentified worker are pictured at the outdoor racetrack on the International Stock Food Farm. Note the information about Dan Patch's record as a sire just below where the men are sitting.

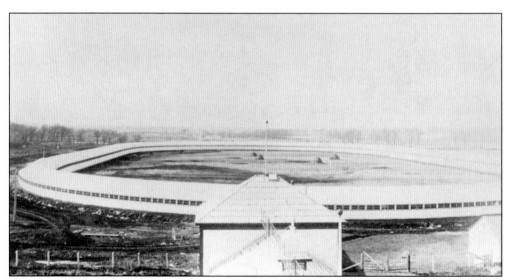

This is a full view of the International Stock Food Farm's covered track. It was enclosed on all sides and attached to the main barn with a short passageway. The track was 30 feet wide and included a grandstand where visitors could watch the horses during workouts. There were also 1,400 windows installed to provide adequate lighting.

The Great Dan Patch is a 1949 American film directed by Joseph M. Newman about the pacer. It starred Dennis O'Keefe, Gail Russell, Ruth Warrick, Charlotte Greenwood, and Henry Hull. The story of Dan Patch was not just his crowning achievement of setting a world record. It was about how the world almost did not get to enjoy him because when he was foaled in 1896 in Oxford, Indiana, he had a deformed left hind leg and had to be held up to his mother to nurse. His owners wondered whether the horse would ever be able to walk, let alone race. When he raced, he had a custom cart to keep his legs from hitting the wheels and custom-made shoes to balance his stride.

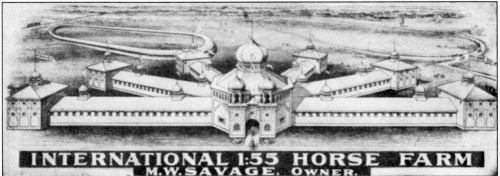

After the deaths of horse and owner, the International Stock Food Farm began to decline. Within two years, Marietta Savage sold her husband's horses. The farm was sold and used for a short while as a dog racing track in the 1930s. The farm and buildings eventually burned down and were never rebuilt. The land is now owned by Cargill, Inc. The outline of the track can still be seen in aerial photographs.

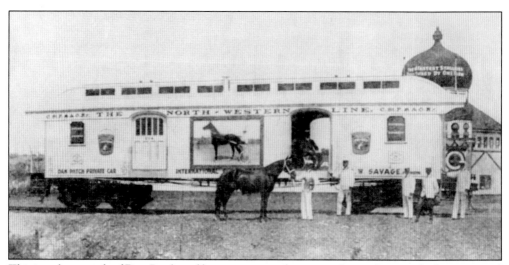

This is a photograph of Dan Patch and his private car taken just as he was leaving the International Stock Food Farm for his extended 1904 tour of state fairs. The car was painted pure white inside and out, and on each side were large oil paintings of Dan framed in heavy plate glass. The roof was painted in aluminum and the entire car was striped in gold. Savage is sitting in the car door. Dan's caretaker, Charlie Plummer, is next to Dan, and H.C. Hersey, his trainer, is wearing the dark-colored trousers.

Bucolic images of the International Stock Food Farm were often used on the cover of International Stock Food Company catalogues.

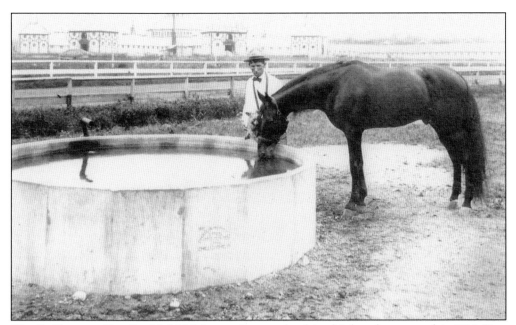

Charlie Plummer, Dan Patch's faithful caretaker, watches him drink at the racetrack in 1910. Dan was mahogany in color with black points and a small white star on his forehead. He weighed 1,165 pounds, was 16 hands tall, had a girth of 73.5 inches, and his shoulder measure was 60 inches. Charlie is holding Dan's mascot, Little Patch.

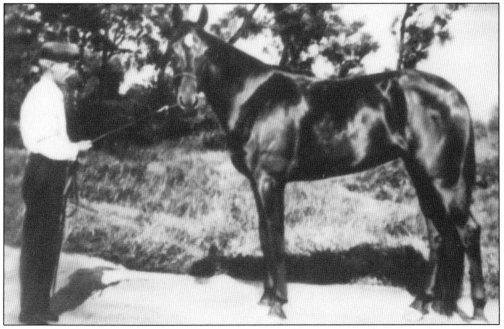

Dan Patch, pictured here with Mike Egan, was described by many as a charismatic horse. He was treated like a star by the thousands who came to see him race. Dan loved the crowds; he would raise his head to them and seem to talk to them. Because of this, many fans viewed the horse as almost human. Before a race, it has been said that he would stroll past the grandstand and lift his head to survey the crowd. "Dan's counting the house," they used to say.

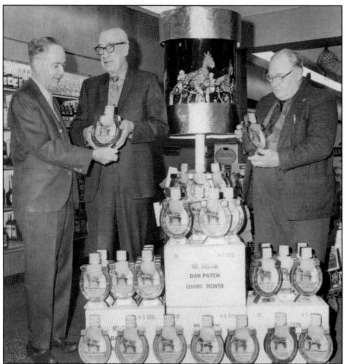

In the 1960s, the Dan Patch Liquor store sold Dan Patch whiskey, shown here in a special display at the store. Pictured from left to right are Harold Savage, Frank Gallagher, and Ben Morlock. When the horse was alive, his name became a household word thanks to the way Savage promoted him. There was Dan Patch tobacco, Dan Patch cigars, and children's toys bearing his name. Housewives did their laundry in a Dan Patch washing machine. Many of these items are now collectibles, valued by many who continue to revere the horse and his legend.

M.F. Zeller, who worked as a maintenance man in Dan Patch's barn, points toward Dan's unmarked grave in this 1954 newspaper clipping. The secret grave is said to be located on what is now Cargill land along the Minnesota River in Savage. The other men in the picture with Zeller are, from left to right, Dan Patch (who went by "David Patch" until he moved to Savage in 1918), Frank Egan, and E.H. Newstrom.

Four

HEROES AT HOME— SAVAGE DURING WORLD WAR II

During World War II, soldiers from Camp Savage and workers from the Cargill shipyards mixed together with local residents on the streets of town.

Camp Savage was a military language school designed to improve the foreign language skills of Japanese-American soldiers, and to train them in military intelligence. A former state Transient Relief camp, it was refurbished for the soldiers.

The city of Savage had access to rail lines and the river, so it was a perfect location for the Cargill shipyards, where 23 ships were built for the military for use during World War II. A sizable investment was made to move equipment from Cargill's Albany, New York, shipyard. Train tracks were also extended into the site, and a nine-foot channel was dredged in the Minnesota River to launch the boats.

The world was at war. While life continued in Savage, there was a different kind of boom taking place. Mayor Charles McCarthy was quoted in the local newspaper as saying that the village had a severe shortage of housing. "We could have 300 more families here today if we had any place to house them," he said.

The village had plans prepared for a housing project and an expansion to the sewer and water system, but because materials were scarce, the project could not move forward. But that did not stop the war effort in town, where work continued at Port Cargill and Camp Savage.

The Savage Tool Company also moved into town during World War II. It manufactured machine tools and precision gauges for the war. The company was later renamed Continental Machines, and is still in operation in Savage.

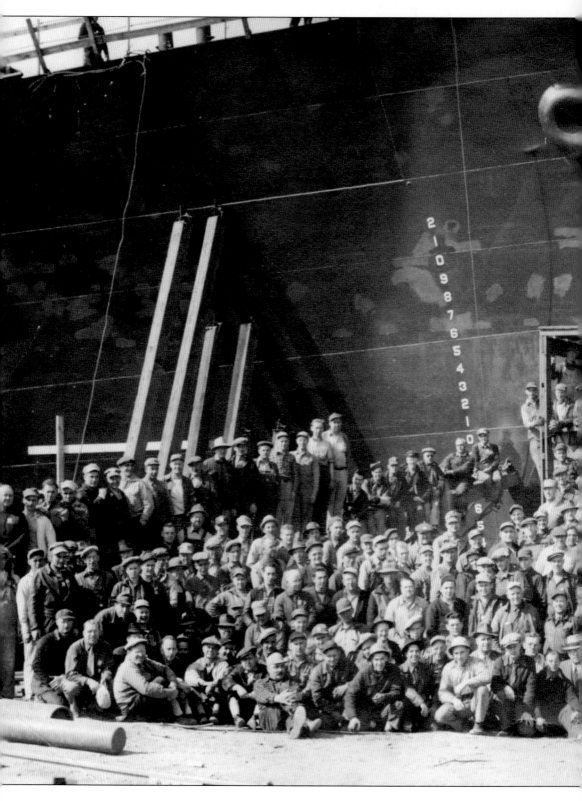

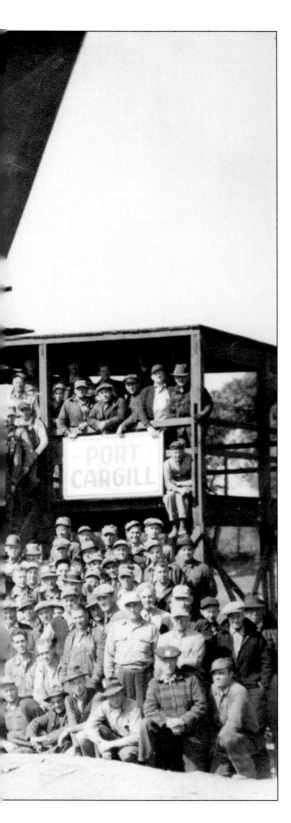

At its peak, the Port Cargill shipyard employed 3,500 people. One of the factors in getting the Navy contract was an ample supply of skilled workers, some of whom are shown here. A total of 23 ships were built at Port Cargill—18 Auxiliary Oil and Gas Carries (AOGs) and five super towboats.

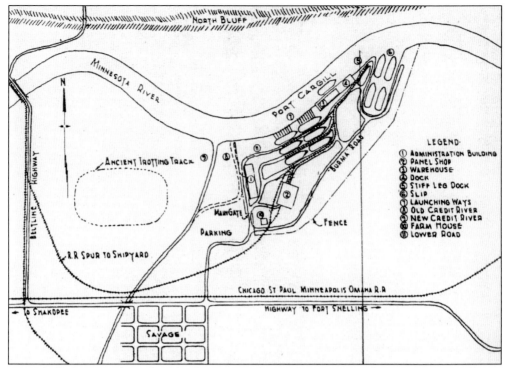

A total of 350 acres of farmland by the river in the northeast corner of Savage and a small area in Burnsville were converted into Cargill shipyards. Some of the land was Ed Hanson's old farm but the majority was the old International Stock Food farm. This map shows the entire area, including Dan Patch's old racetrack, the railroad, the river, and the village of Savage.

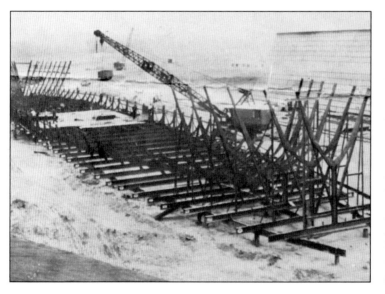

The July 15, 1945, edition of the *Minneapolis Sunday Tribune* showed a full page of photographs depicting the shipbuilding process at Port Cargill after the US Navy lifted censorship. After the pattern had been cut and shaped in the panel room, the steel plates were taken to the jig and welded together to form a section of the hull.

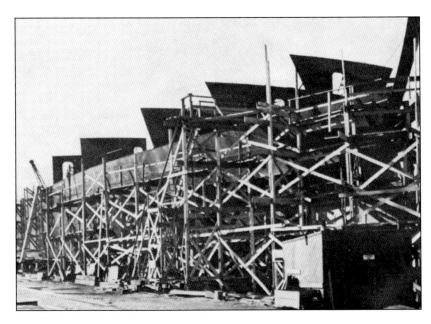

From the jig, the bottom sections of the hull were welded to the other sections. It took six weeks from the start of construction to the keel laying.

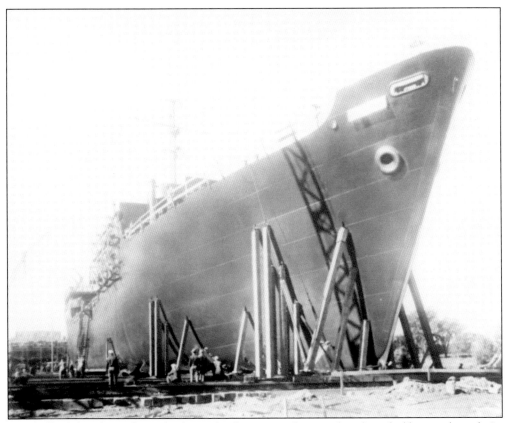

The hull of this ship is being built up. At this point, the vessel is about halfway to launch. In addition to tankers, five towboats were built by Cargill, which began building ships in 1937 in Albany.

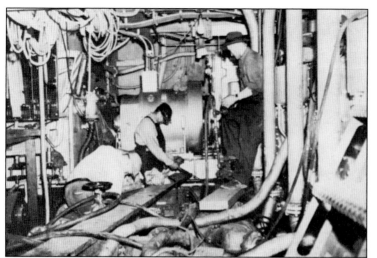

After the ship was launched, it was fitted out. Pictured from left to right, William Carson of LeSeur, R.L. Tiffany of St. Paul, and Philip Raskin of Minneapolis work among a maze of tubing, pipes, and wiring in the engine room.

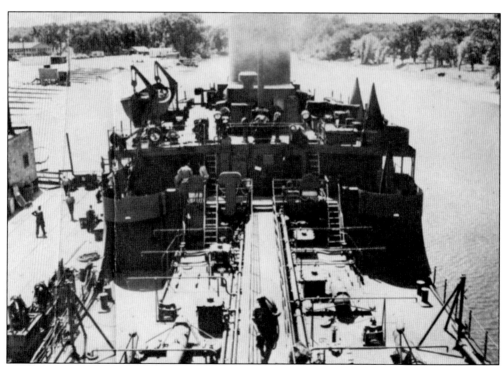

At this point, the ship work at the yards had been completed and the ship was ready for its trial run. The vessel is powered by four main propulsion diesel generators that provide power to drive the propulsion motors. Two propellers are geared to the motors.

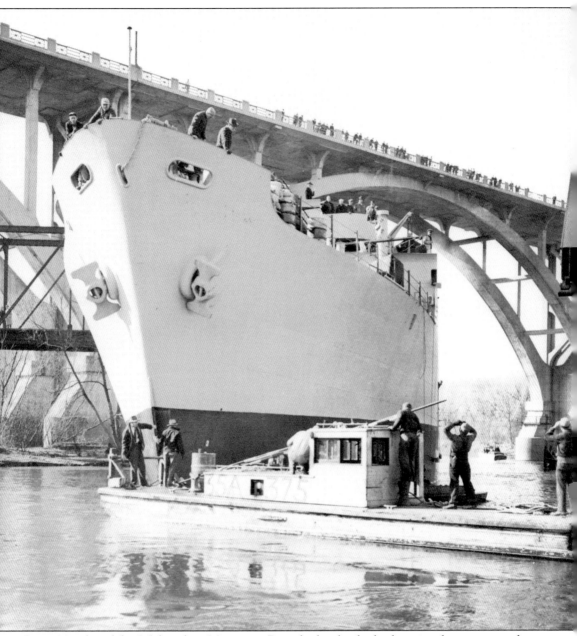

Some 14 miles of the 3.5-foot deep Minnesota River had to be dredged to nine feet at a cost of $250,000 before AOGs like this one could pass underneath the Mendota Bridge to make it to the Mississippi River in St. Paul and on to New Orleans for final installations before going into duty for the Navy. The tankers were officially named for rivers and were mostly Indian names. The original contract was for six ships. The *Agawam* (AOG 6) and *Elkhorn* (AOG 7) were the first to be delivered, in April 1943, and the *Genesee* (AOG 8), *Kishwaukee* (AOG 9), *Nemasket* (AOG 10), and *Tombigbee* (AOG 11) were delivered in October of that year. Other ships included the *Chehalis* (AOG 48), *Chestatee* (AOG 49), *Chewaucan* (AOG 50), *Maquoketa* (AOG 51), *Mattabessett* (AOG 52), *Namakagon* (AOG 53), *Natchaug* (AOG 54), *Nesplen* (AOG 55), *Noxubee* (AOG 56), *Pecatonica* (AOG 57), *Pinnebog* (AOG 58), and *Wacissa* (AOG 59).

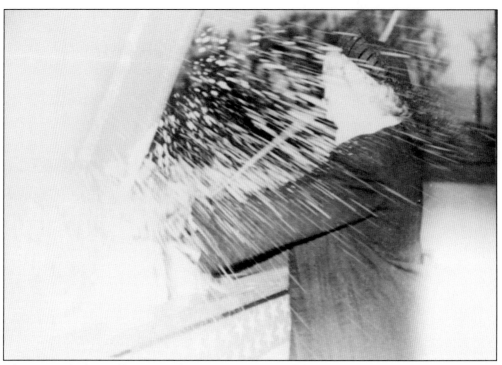

The Navy asked Cargill not to make major events out of ship launchings, and for the most part the company complied. But it did carry out a few launching ceremonies, one of which is shown here as Rebecca Hanson, the USS *Nemasket*'s sponsor, christens the ship. Cargill purchased 86 acres of farmland from her husband, Ed Hanson, to build the shipbuilding facility.

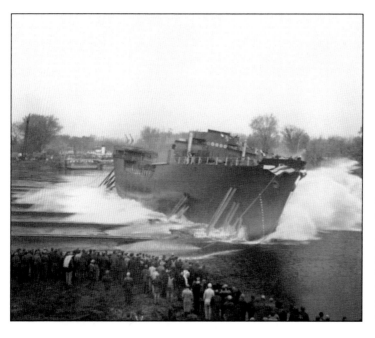

The USS *Nemasket* was one of 18 AOGs launched into the Minnesota River at Savage. The Nemasket was laid down October 6, 1942, by Cargill and launched on October 20, 1943. It was commissioned June 16, 1944, in New Orleans, Louisiana. AOGs were not engaged in actual warfare activity, but were used to carry fuel for other ships and vehicles in the war.

A total of five super towboats were built at Port Cargill. The towboats were built for the Defense Plant Corporation (DPC) and the Army. The first towboat, the *Bataan*, was launched in September 1943. Other towboats launched at Savage included the *Coral Sea*, *Milne Bay*, *Bou Arada*, and *Tenaru River*.

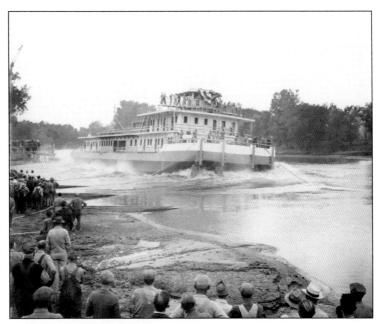

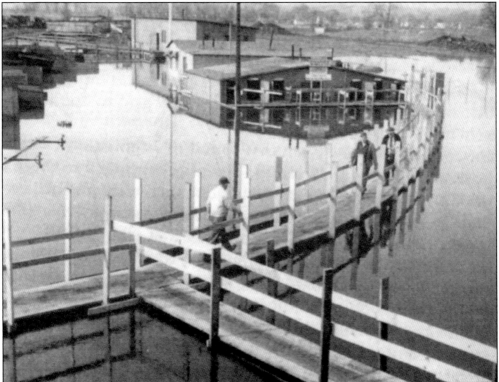

The Minnesota River flooded in the spring of 1943, pushing the river 13 feet above its normal levels. Work at Port Cargill needed to continue in order to meet the Navy's deadlines, so temporary, elevated walkways were created to allow workers to carry on. The floodwaters had barely subsided when, on May 6, 1943, the *Agawam* slid sideways into the Minnesota River for Port Cargill's first launch.

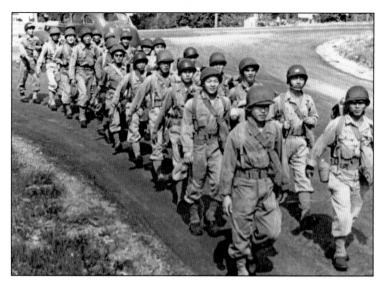

Savage was involved in shaping the nation's history during World War II in another way, with the Military Intelligence Language School, or Camp Savage. In 1942, the school opened at a former Transient Relief camp to improve the foreign language skills of Japanese-American soldiers and train them in military intelligence.

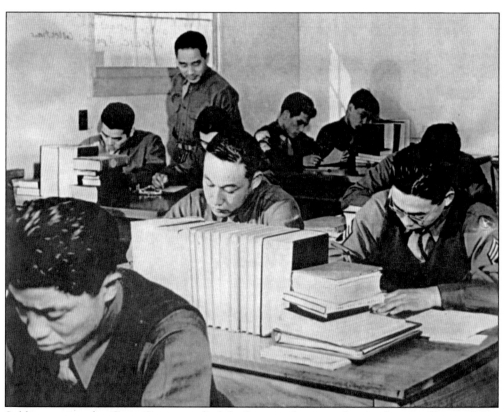

Soldiers stationed at Camp Savage studied the Japanese language for nine hours a day, receiving a 90-minute lunch break and a 2.5-hour dinner. They typically had their weekends free. Second generation Japanese-Americans, called *Nisei*, were chosen to attend the school. Those who completed classes were stationed throughout the Pacific and in Alaska.

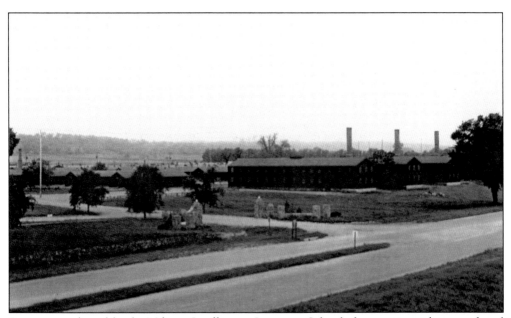

Savage was selected for the Military Intelligence Language School after a nationwide survey found Minnesota to have the best record of racial amity. Language school commandant Col. Kai E. Rasmussen said he believed Savage was a community that would accept Japanese-Americans for their true worth—soldiers fighting for their country with their brains.

The first classes began at Camp Savage on June 1, 1942, with a total of 200 soldiers and 15 instructors. Within two years, the school grew to have 52 academic sections, 27 civilian and 65 enlisted instructors, and 1,100 students. The school was first established in 1941 at the Presidio in San Francisco. But after Pearl Harbor, in the interest of national security, Japanese Americans were evacuated from the West Coast. By August 1944, the school had outgrown the Savage location and was moved to Fort Snelling.

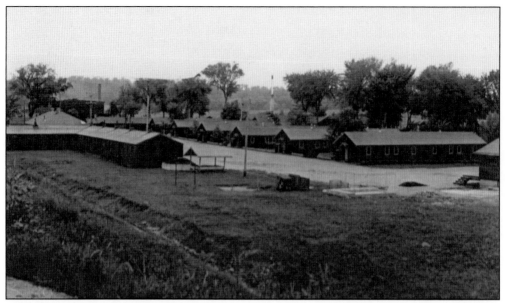

The 132-acre Camp Savage site was located south of what is today Highway 13, near Xenwood Avenue. The site had been used by the Civilian Conservation Corps during the 1930s, and afterwards by a state Transient Relief program that housed elderly, indigent men. Accommodations were sparse at first, but the site eventually consisted of barracks, a mess hall, classrooms, a radio shack, an auditorium, a gymnasium, and an officers' mess. Today, there is a historical marker along the highway with a flagpole and a bench. A portion of the site is now fenced in for a dog park. No buildings remain on the site, but several of them were purchased by residents, moved, and converted into homes scattered throughout the downtown area.

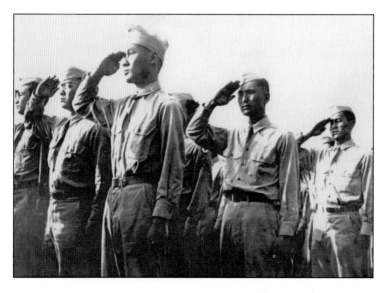

English-speaking Nisei from the West Coast learned the Japanese language in order to serve the Allied Forces in the Pacific. The trainees went on to work with combat teams to interrogate prisoners from the front lines. Others were trained as paratroopers and dropped into enemy territory to ascertain enemy positions, strengths, and plans.

Five

COMMUNITY BUILDERS

A community does not build itself. People may come to a town to start a business or because they have relatives in the area, but they stay because of the store on the corner, a particular proprietor, or the town leaders who make the town better.

Some people stay because they like the church and the opportunities that religion offers them. Others enjoy the natural amenities in the area—the rolling hills that make for fertile fields, the abundance of fresh water, and the opportunity to make a living.

All of these things combine to help build a town's character and that is when the community starts taking shape. This chapter is dedicated to those community builders: the service clubs, fire and police departments, elected officials, businesses, and churches that have made Savage a great place to live.

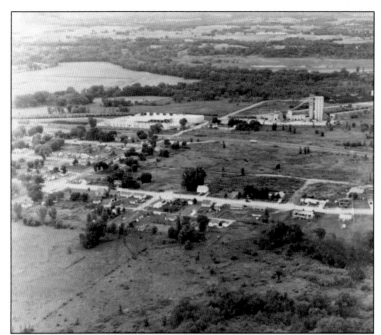

This aerial photograph of Savage was taken in 1956. At the time, the town was only one square mile. The township of Glendale made up the rest of present-day Savage.

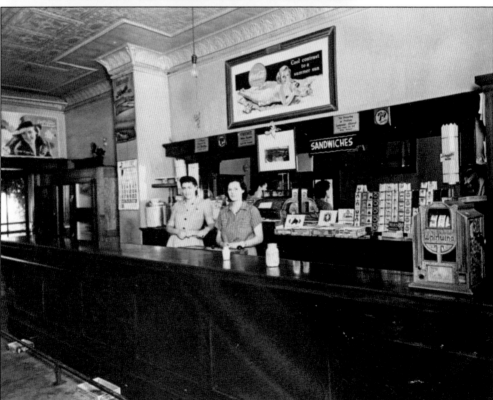

Virginia Coakley Emerson and Irene Kaufenberg are pictured around 1940 behind the bar in the Kaufenberg building, located on the corner of what is now 123rd Street and Ottawa Avenue. Note the slot machine at the end of the bar. The building is still there but has undergone several renovations.

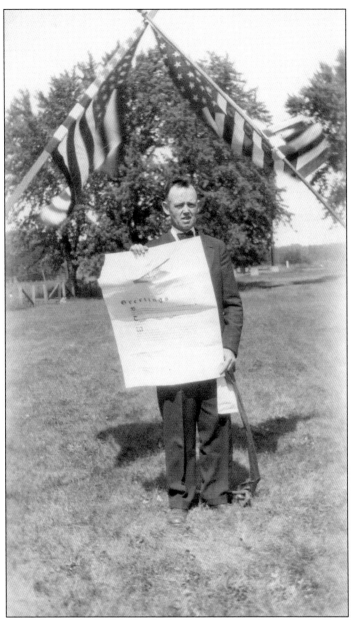

In this 1927 image, Mayor Charles McCarthy holds a greeting that Charles Lindbergh dropped over Savage while on his tour of the United States after his historic nonstop flight over the Atlantic to Paris. The greeting was a token of Lindbergh's appreciation for the community that had befriended him. In 1923, Lindbergh was flying in a World War I Curtis Jenny to Shakopee to join his father on a campaign stop when bad weather forced his plane down in a swampy area along the Minnesota River, where Cargill is now located. The crash drew the attention of townspeople. Local residents helped pull the plane to hard ground and Lindbergh wired for a new propeller, which arrived a few days later. While in Savage, Lindbergh stayed in the Savage depot, enjoying the hospitality of Mayor McCarthy, who was also the Savage depot agent. The cracked propeller is in the possession of the Minnesota Historical Society and on display at the Lindbergh home in Little Falls.

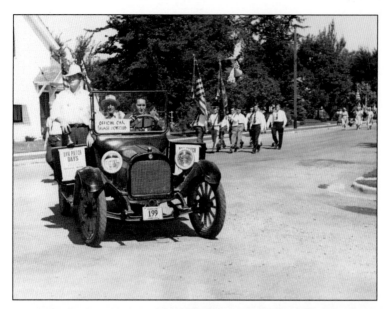

Each year, the Dan Patch Days Parade "official car" made the rounds to make sure everything was in order. Here, in 1953, organizers of the first event made their way around a corner ahead of the parade. Pictured here, from left to right, are Ed McQuiston, Dave LaLond, and George "Sonny" Allen Jr.

Ben Morlock, pictured here in 1962, sells a Dan Patch Days button to Eleanor Casperson. Although many civic organizations, including the VFW Club, the American Legion, the Savage Fire Department, and the Lions Club worked together to make the annual festival a success, Morlock's dedication to the celebration was unmatched.

Vine Street (now Ottawa Avenue) is pictured as it looked in the 1930s, looking north from what is now 123rd Street. Frank Egan's café and the city liquor store are the two closest buildings.

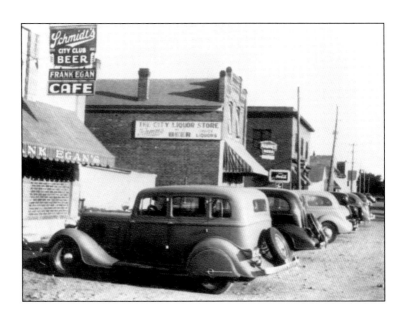

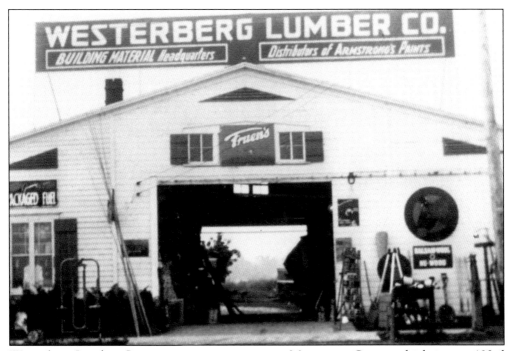

Westerberg Lumber Company was a mainstay on Minnesota Street, which is now 123rd Street. It was originally Arnoldy Lumber Company and was purchased by Ken Westerberg in the early 1940s.

This is what Kearney's Store looked like in 1945. The grocery store was actually two old Camp Savage log buildings, with the grocery store in the front building and the back building serving as the Kearney family home.

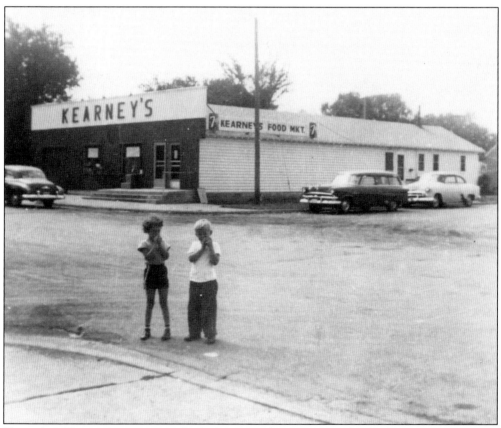

Here is how Kearney's grocery store looked in 1954 after it was remodeled. The store faced Ottawa Avenue at the corner of 124th Street. Shown here are Kathy Mott and Dennis Oian.

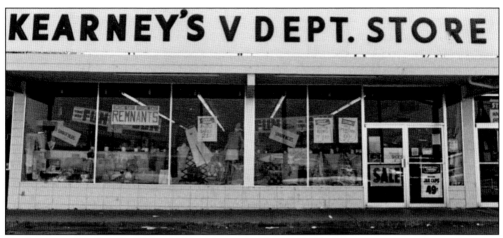

KEARNEY'S V DEPT. STORE

As the years went by, the Kearney family continued to create businesses to serve the community. The V-Store was built next to the grocery store and offered all sorts of merchandise popular in five-and-dime stores of the day. Jim Brady's Drug Store and Bloomquist Hardware were also in the mall. Kearney's Grocery was eventually sold and became Bob's IGA. Once Bob's IGA went out of business, the Savage post office moved into the spot. The mall still stands and now includes a karate school, a construction business, a music store, and a Laundromat.

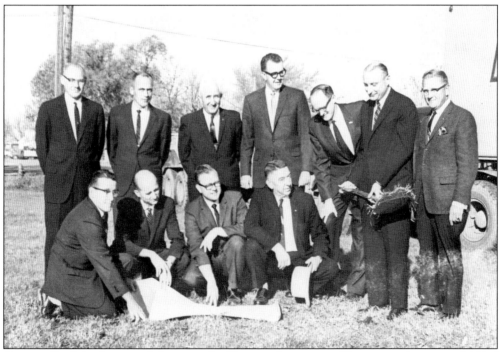

Security Bank broke ground for a new building at the corner of Princeton Avenue and 123rd Street in 1960. Pictured here are, from left to right, (first row) Gene Kearney, John Gargaro, unidentified, and Howard Huston; (second row) Al Schunk, John Signlewold, Mark Egan, Merrill Madsen, Dan O'Connell, James Algoe, and Stan Nordstrom.

This photograph was taken in front of the old city hall in the 1930s or 1940s before the volunteer Savage Fire Department was formerly chartered. William Lattery is fourth from the left, and George Kline is on the far right. The other men are unidentified.

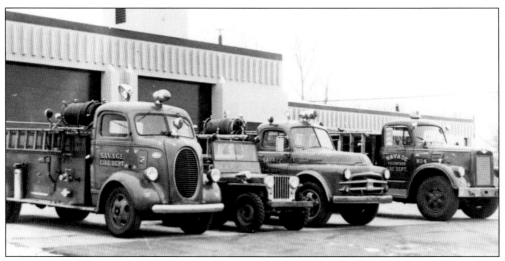

This was the fire department's fleet when it moved into the new city hall and fire department building on the corner of Quentin Avenue and 123rd Street in 1965. Previously, the fire department operated out of an old machine shop where the trucks barely fit into the narrow stalls. For a time, the fire department, city hall, and the police department all operated out of the building. When city offices and the police department moved into the new city hall on McColl Drive in the 1980s, the fire department took over the Quentin Avenue building. That building was torn down in the summer of 2011 after a new fire station was constructed on McColl Drive, near City Hall.

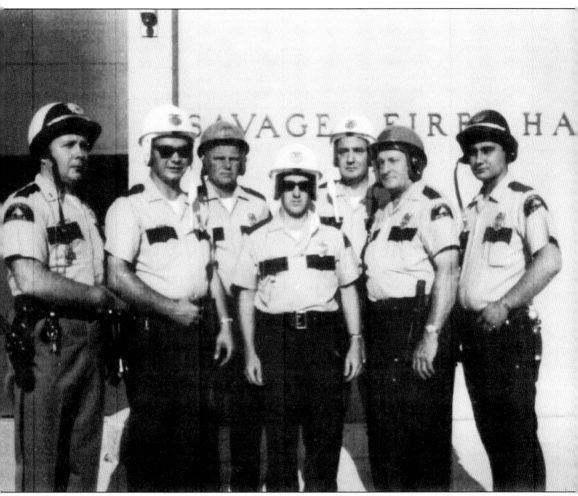

The Savage Police Department was formed in 1958 when the city hired its first police chief, Richard J. O'Keefe. The police department was in the basement of O'Keefe's house until 1965, when the chief was able to hire his first patrol officer and move to an office in the fire station. At the time, the Savage Police Department was known for having one of the top training programs for reserve officers in the state. This photograph from the 1960s shows the police reserve and part-time officers, from left to right, Bob Nasstrom, Michael Regentz, Bob Widmer, Don Gray, Dana Smith, Frank Potasik, and Dan Johnson. The reserve program operated until 1977 when the state mandated licensing requirements for all police officers in Minnesota. Although the city of Savage disbanded the reserve staff, it did keep some of the part-time officers so the city would have 24-hour police service. Chief O'Keefe retired in 1984 and there have only been two police chiefs since: Gordon Vlasak and Rodney Seurer.

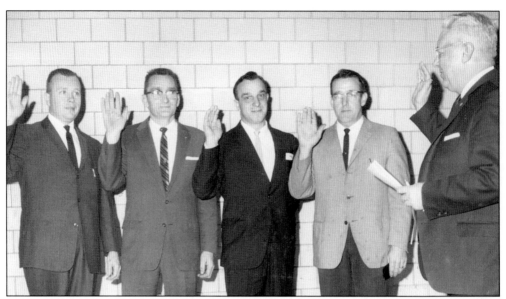

City clerk John Bergman swears in members of the Savage City Council after an election in 1964. Pictured from left to right are councilmen Robert Nasstrom, John Knutson, Len Julkowski, Gene Kearney, and clerk John Bergman.

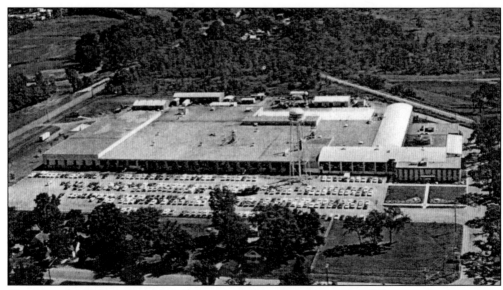

Continental Machines moved to Savage in 1946 and remains part of the community, still in its original location along Highway 13, adjacent to the downtown area. Precision saws for steel cutting and other uses are made at the plant and sold all over the world.

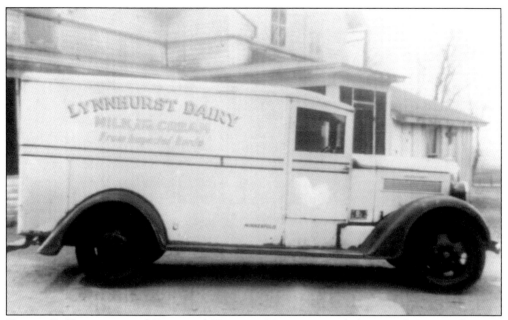

Kristen B. Kristensen and Einar and Kristensa Hansen rented the Tim O'Reagan farm on Highway 13 in Burnsville in the mid-1920s. They started Lynnhurst Dairy with a milk route in South Minneapolis. Jens Bohn Sr. and Jens Caspersen drove the two delivery trucks. In 1938, Kristensen moved to the John O'Reagan farm and started Lynnhurst II on the corner of Nicollet and Highway 13 in Burnsville. (Photo courtesy of Janet Bohn Williams.)

K.B. Kristensen moved Lynnhurst to Savage in 1942, and Jens Bohn Sr. continued to deliver milk to South Minneapolis until 1953, when delivery routes were discontinued because raw milk could no longer be delivered in Minnesota. Dairy farming at Kristenson's farm continued until 1968, when the cows were sold at auction. Today, Paul Williams owns the property and uses the barn to store tires for the Paul Williams Tire Company in Minneapolis. (Photo courtesy of Janet Bohn Williams.)

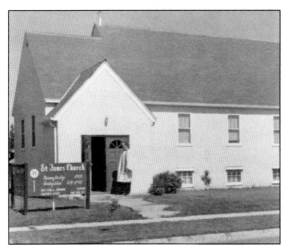

St. James Lutheran Church came to Savage in 1939 and, a few years later, erected a building on the corner of Burns and Main Streets (what is now Princeton Avenue and 124th Street). The first services were held in 1944 in the basement of the new building. When the congregation outgrew that building by the 1960s, plans were made to buy property in Burnsville, just across the Savage city line on Williams Drive. The old church was bought and used by All Type Printing for a short time and then became home to the Dan Patch American Legion, which used it as its club and bar before it was torn down to make way for a new American Legion building, which still operates at that location today.

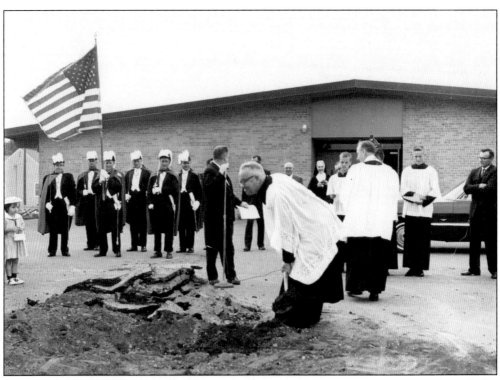

St. John the Baptist Catholic Church's prominence in the community grew in 1959 with the dedication of a new school and convent. In 1964, an addition was added to the school, including an auditorium. Pictured here, from left to right, are Father Phillip Finnigan, Father Francis Dudley, Sister Pauline Fritz, several unidentified alter boys, John Mulligan, and John Metcalf. Members of the Knights of Columbus included, in no particular order, Eugene Kearney, Frank Varacek, William Lannon, Ed Giles, Robert Egan, and Sylvester Wacher.

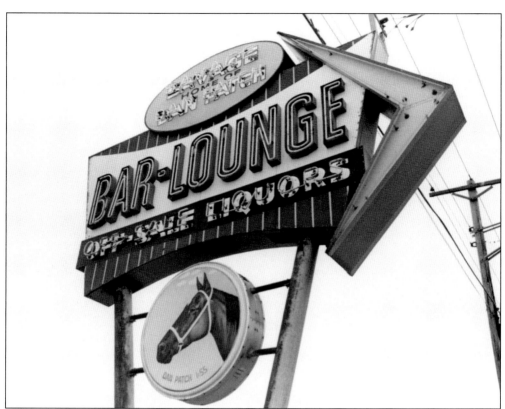

The Dan Patch Lounge, affectionately known as "the Patch," was a popular gathering place for years. On one side of the building was the off-sale liquor operation, and on the other side was the bar. At one time, the town of Bloomington did not allow liquor sales, so folks from north of the river would come over the Minnesota River on the one-lane bridge to have a few drinks at the Dan Patch Lounge.

The State of Minnesota gave cities the option of operating their own liquor stores or allowing private enterprises. Savage opted to start a liquor operation. George Egan (left) was the proprietor of the city's liquor store and is pictured here in the 1930s or 1940s with Doris Hanson Bergman.

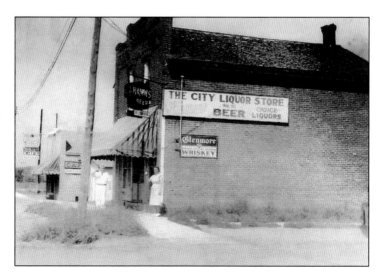

The Warren Butler VFW Post 6212 was chartered in February 1946 and was one of two veterans' organizations in the community. In this 1953 Dan Patch Days parade, the ladies auxiliary was represented by, from left to right, Doris Bergman, Pearl Cook, Maristella Korba, Iona Knopf, Carol Dwyer, Hazel Badke, Lorraine Kenneally, and Emma Coakley.

In 1960, new officers of the Dan Patch American Legion Club sign the official paperwork. Pictured from left to right are Daniel Engler, Harold Lachelt, Robert Burton Jr., and Merrill M. Madsen. (Courtesy of the Dan Patch American Legion.)

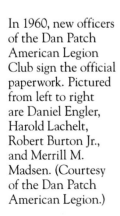

Don Zander, commander (left), and Lloyd Byzewski, sergeant-at-arms (right) presented Mr. and Mrs. Vincent Mott, of Savage, a plaque in memory of their late son, Cpl. Barry Mott, a 1964 graduate of Burnsville High School, who was killed in Vietnam in July 1966. (Courtesy of the Dan Patch American Legion.)

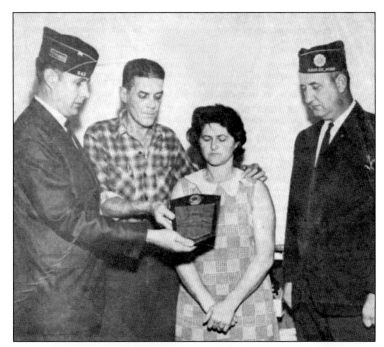

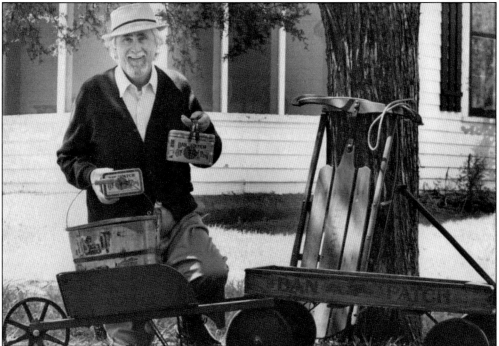

Joe Egan shows off artifacts from his Dan Patch collection. Egan and his wife, Jean, lovingly kept the memory of Dan Patch alive for decades. Joe developed his love for the pacer after his father, George Egan, showed him a flip book of Dan Patch. His cousin, Mike Egan, was the last groomer and handler of Dan Patch. Joe and Jean, who began collecting Dan Patch memorabilia in the 1950s and had a large collection of it, were proponents of building a Dan Patch museum where the stables were located.

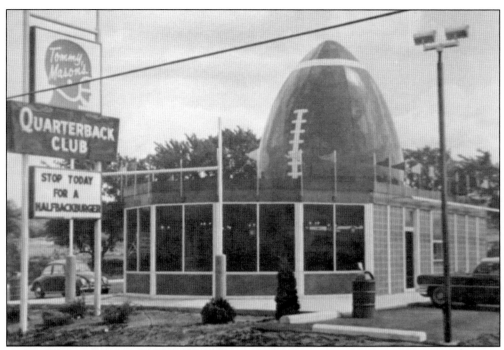

Here is Tommy Mason's Quarterback Club as it looked in 1966. Located on Highway 13, the restaurant gave way to a "Feed and Seed" and the football was painted like an ear of corn. The building was torn down in the late 1990s.

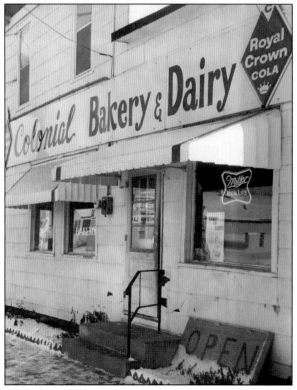

The Colonial Bakery and Dairy was located on Ottawa Avenue, across from Dan Patch Lanes. It was owned by Bill and Mabel Cunningham.

Six

PASTIMES AND CELEBRATIONS

Baseball games, talent shows, Sunday picnics, and community celebrations create the memories people cherish for years and years. In Savage, there have been plenty of those memories, and many of them have been made during Dan Patch Days. The celebration was started by volunteer organizers from the Savage Lions Club and the Savage Fire Department who were soon helped by friends from the Dan Patch American Legion and the Warren Butler VFW. It started small, with a queen contest, kiddie parade, horse races, and a rodeo. It continues today with four days of activities for all ages and brings 10,000 people every June to Savage Community Park.

Baseball also brought the Savage community together. Teams date back to the early 1900s and have always had a loyal following.

When it came to enjoying the city's natural amenities, there was Egan's Hidden Valley Ranch, which included a lodge, picnic grounds, ski hill, and bridle path. People would come from miles around to enjoy horseback riding, picnics, and dances. The Egan family sold the land to the city and it is still enjoyed as a city park where people can gather for picnics, hike on walking paths in wooded areas, sled down the sliding hill in winter, or simply enjoy the beauty of the Credit River.

And even though the International Stock Food Farm was no longer operating, there was a short-lived effort to run a dog-racing track from the old farm in the late 1920s and early 1930s. The venture ran afoul of state authorities who said the use conflicted with anti-gambling laws.

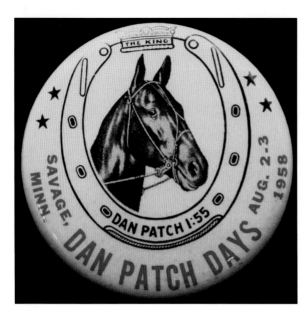

Sales of buttons, such as this one from 1958, have been made every year to promote Dan Patch Days since the community celebration started. Now they have become collector's items. Over the years, the use of the buttons has changed. For instance, the Dan Patch Days Queen and her court were chosen in 1953 based on how many buttons they sold. In later years, the buttons were used as a way to get discounts at the festival. Nowadays, the buttons are used to create awareness, but also as an incentive for a horseshoe hunt. The winner gets a cash prize and rides in a carriage in the annual parade. (Courtesy of Mark Roberts.)

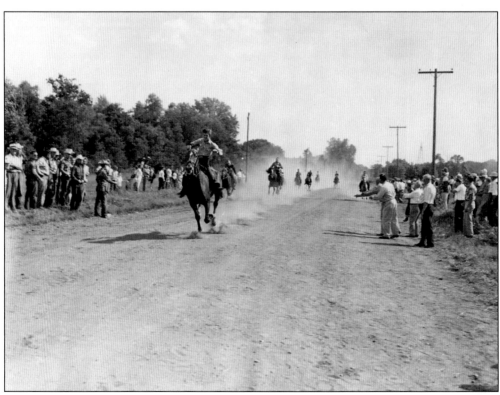

Dan Patch Days always included plenty of events, and in the early days those often centered on horses. In this photograph from the mid-1950s, boys race horses down what is now Quentin Avenue. There was a race for girls as well.

Lois Breggeman was the first Dan Patch Days queen in 1953.

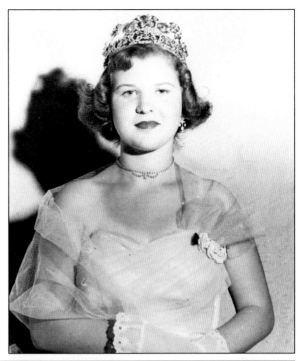

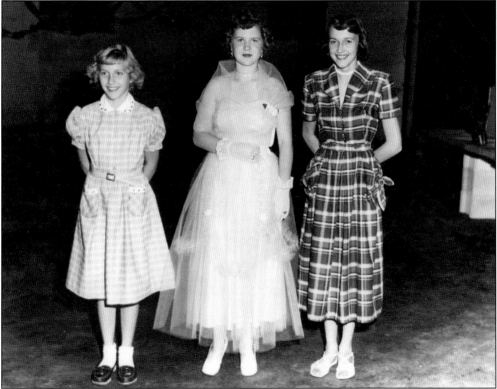

The Dan Patch Days court in 1953 featured (from left to right) Connie Emerson, queen Lois Breggeman, and Carol Sue Boche.

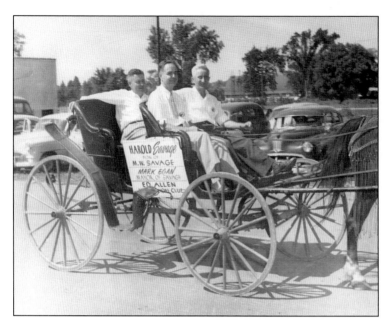

Harold Savage, M.W. Savage's youngest son, graciously served as a grand marshal for Dan Patch Days on many occasions. Harold (middle) is shown in the grand marshal cart with Eddie Allen (left), representing the Lion's Club, and Savage mayor Mark Egan (right).

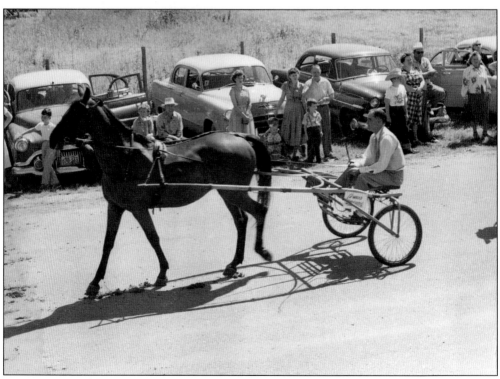

Native son Harold Savage rides in a sulky behind a horse in a 1950s parade.

The annual kiddie parade in the 1950s was a great way to involve the children in Dan Patch Days. Pictured here from left to right at the front of the line are Peggy Kearney, Mary Kay Kearney, Dawn Ann Bergman, and Kathy Doebel.

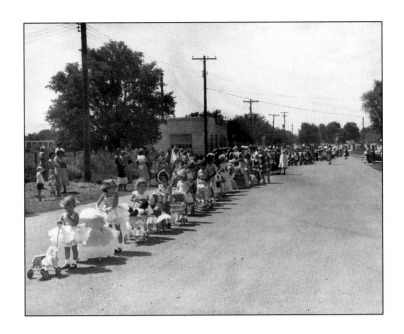

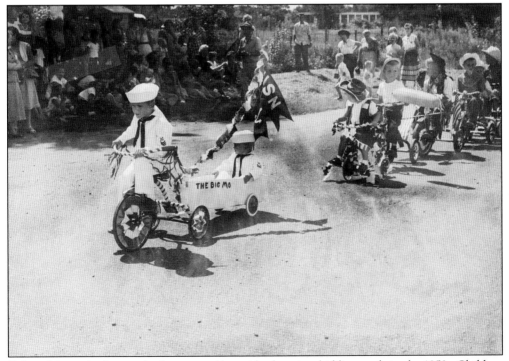

Bob and Scott Anderson, the front two riders, ride along in a kiddie parade in the 1950s. Children dressed up in different costumes for the parade. Parents and residents lined the streets to cheer them on.

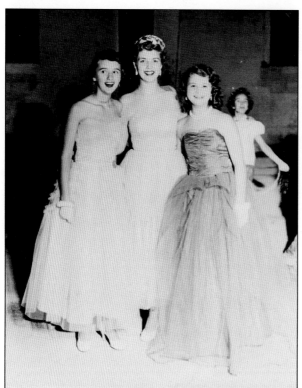

The Dan Patch Days 1954 royalty included, from left to right, Janet Bohn, queen Ramona Noonan, and Nancy Oster. Janet Bohn is now Janet Williams, current mayor of Savage.

Ramona Noonan was the Dan Patch Days queen in 1954.

Bob Dean rides the rodeo at Dan Patch Days in 1953. The Western theme was prevalent throughout the 1950s and 1960s in Pacer Park.

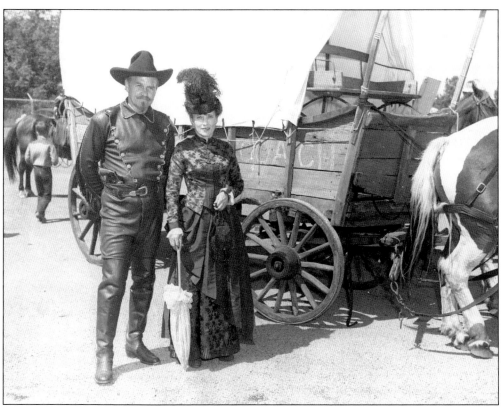

Osborne "Ozzie" and Marie Klavstad show off their stylish clothes here in 1953. They owned the Stagecoach Restaurant on the Savage/Shakopee border and were mainstays at Dan Patch Days.

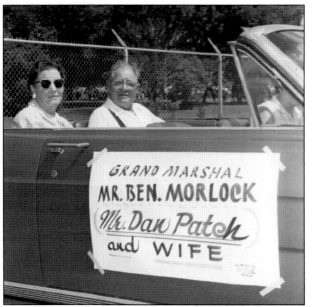

Ben Morlock and his wife, Grace, are pictured here in the 1960s, when he served as grand marshal of the Dan Patch Days parade. Morlock was a dedicated volunteer for the celebration honoring the memory of the famous pacer. With the help of his fellow Lions Club members, Morlock founded Dan Patch Days and served as chairman for about 10 years. Morlock was instrumental in directing the proceeds from the celebration towards activities that benefited the community, in particular the annual Savage Civic dinners. Morlock was also a justice of the peace in Savage, holding court every Saturday night in the old Savage fire hall.

In the mid-1950s, with their hands behind their backs, these watermelon-eating contestants are ready to dig in with just their mouths. Eating contests are still a part of Dan Patch Days, but now they involve eating hot chicken wings or baked pies.

This postcard promoting the town includes, from left to right, St. John the Baptist Catholic Church, M.W. Savage's Valley View home, the Dan Patch Railroad Bridge and, of course, the home of Dan Patch, the International Stock Food Farm.

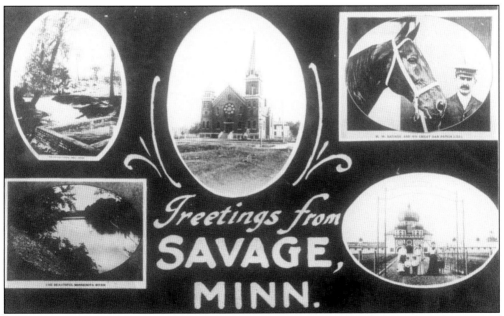

"Greetings from Savage, Minn." proclaims this early 1900s postcard, filled mostly with images of the International Stock Food Farm. Pictured are (clockwise from top left) the natural springs on the farm, St. John the Baptist Catholic Church, M.W. Savage with Dan Patch, the front gate of the International Stock Food farm, and the Minnesota River.

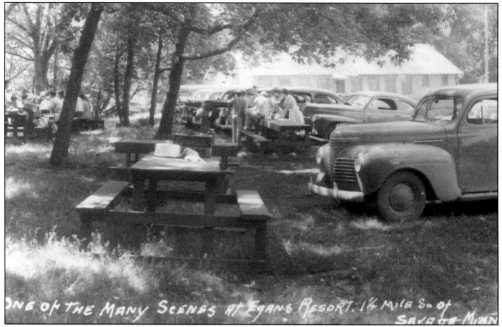

ONE OF THE MANY SCENES AT EGANS RESORT. 1½ MILE So OF SAVAGE MINN

Egan's Hidden Valley Lodge was a gathering place in the 1930s and 1940s and is now a city park. Michael Egan settled in Glendale in the late 1800s in a log cabin on a hill along the Credit River. Over the years, the Egan land was developed into Egan's Lodge and included two ski runs. But it was also known as a great place to gather for a picnic. It first went by the name Egan's Picnic Grounds, but that sounded too much like Eaton's Ranch on Cedar Avenue. Ted Cook, one of the employees, came up with the name Hidden Valley.

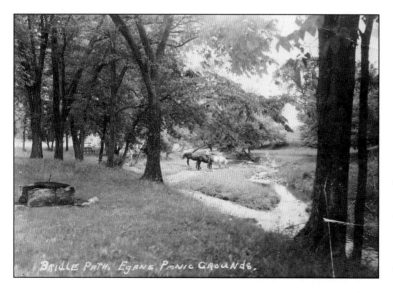

BRIDLE PATH, EGANS PICNIC GROUNDS.

The bridle path along the Credit River, depicted here in a 1940s postcard, was another attraction at Egan's Hidden Valley Resort.

The fireplace at Egan's Lodge was a natural draw, as seen here in the 1930s or 1940s. Even though the lodge burned down years ago, the fireplace still stands and is at one end of a picnic shelter in the new city park. The fireplace was made by Ted Noonan from stones gathered from all 50 states.

Horseback riding was one of the many attractions at Egan's Hidden Valley Resort in 1942. Here Ray Egan and Pearl Hynes ride one horse while Micky Hynes and Ceil Egan follow on another. (Courtesy of Ray Egan.)

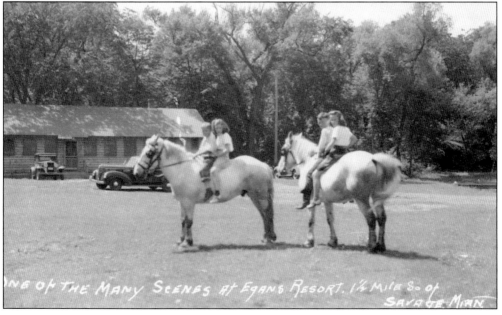

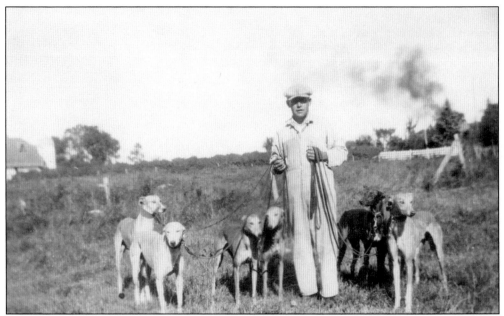

Wes Belz is shown in this August 2, 1928, photograph with some of the greyhounds housed at the dog track that operated on the grounds of the International Stock Food Farm.

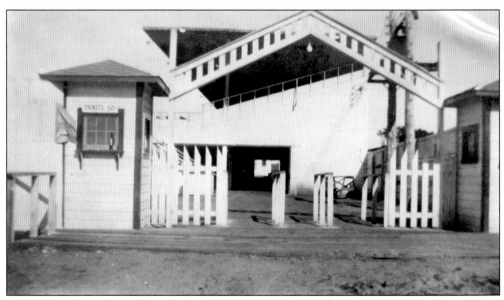

In 1928, a syndicate opened the dog racing track on part of the old International Stock Food Farm. The old racetrack grade was used for the track. State authorities shut it down because gambling was illegal in Minnesota. New attempts with different financial arrangements were attempted in 1930 and 1932, but those efforts eventually collapsed as well.

The Esther Bowles Dance Troupe performs at a talent show at Savage Elementary School around 1953. Dancing on stage are, from left to right, Audrey Shelton, Francis Kenneally, Lorraine Trost, Wilfred Williams, Nancy Oster, Jens Bohn, Mary Lou McCann, and Jerome Allen.

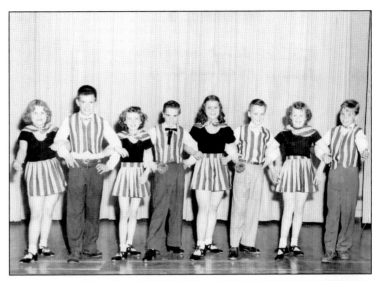

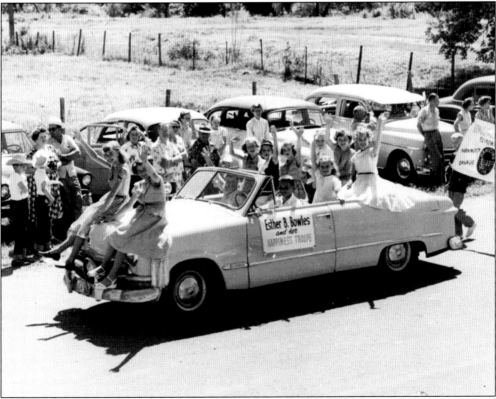

The Esther Bowles Happiness Troupe was a crowd favorite, whether the group was performing, or appearing in the Dan Patch Days Parade, as shown here in 1953. Esther Bowles taught thousands of students dance from the 1940s through the 1970s in Savage, Bloomington, Burnsville, Lakeville, and Shakopee. The Happiness Troupe was a group of 40 dancers who entertained at a variety of venues over the years. Esther passed away in 2011 at the age of 91. Her motto, "Keep Smiling," was a way to encourage her students to dance through any missteps; if they kept smiling, the audience would never know the difference.

The ladies pose for the camera at the 62nd birthday celebration for William Lattery in the 1940s. Pictured here (from left to right) are Sadie McCoy, Grace Morlock, Stasia Kearney, Mary Foley, and Clara Kearney.

The men also gathered for a group picture at the party. From left to right are Robert Allen, William Lattery, George Coakley, and Charles Kline.

What better way to pass the time than with friends? Here, from left to right, Bruce McColl, Elroy Hennen, Don Egan, and Don Hanson meet each other on Vine Street in the mid-1940s.

And now, the girls: Rita McQuiston, Yvonne Whitley, Shirley Riley, Jane Egan, and Maddie McCarthy gather together downtown in 1943.

The dredge line to the Minnesota River that was created from the activity at Port Cargill made for a great ice skating rink for youths in 1943. On the other side of the riverbank is Valley View, which at that time had been sold to the Masonic Home and was being used as a nursing home.

This group of students is out enjoying the nice weather and posing for a picture outside the Savage Restaurant in 1942.

In this undated photograph, Marty Allen, George Egan, and Bill Egan strike a pose.

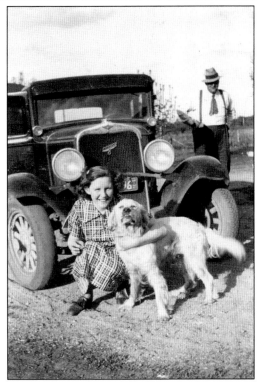

Sometimes memories are made from everyday things, like taking a Sunday ride. Helen Riley Kelleher poses with the dog as George Kline looks on.

This early-1900s baseball team featured, from left to right, (first row) John Carr, George Allen, Tom Duffy, and Martin Cooney; (second row) Mark McDonald, John Egan, John Brennan, George Coakley, and James Brennan.

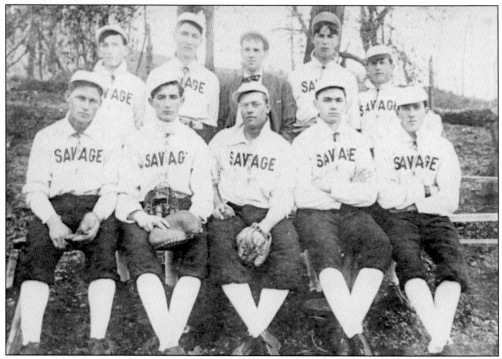

In 1909–1910, the Savage baseball team featured, from left to right, (first row) Fred Coakley, Tom Duffy, Andy Studer, Norm Dahlberg, and Tom Fahey; (second row) Mark McDonald, George Allen Sr., Ernie Sanderson, George Coakley, and Mike Zeller.

The 1942 Dakota County Champions hailed from Burnsville and many of the team members were from Savage. This was the last team that played before World War II. The team resumed playing in 1946. Pictured are, from left to right, (first row) Owen Connelly, Jim Slater, Pat Connelly Jr., Bob Johnson, and Wes Lane; (second row) Dick Kehnenman, Joe Kennelly, Marty Gallagher, Bartley McAndrews, and Pete Louricas; (third row) Harold Egan, George (Sonny) Allen, Morgan O'Brien, Herb McDonald, Eldon Bunker, and Red Devney.

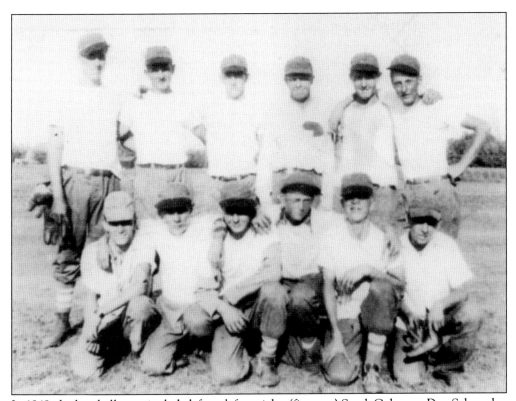

In 1949, the baseball team included, from left to right, (first row) Scrub Coleman, Don Schroeder, Elroy Hennen, Dana Ess, Don Olson, and Pat McLaughlin; (second row) Ronnie Noonan, Russ Egan, Dan Hanson, Don Hanson, Harvey Conrad, and Ken Schroeder.

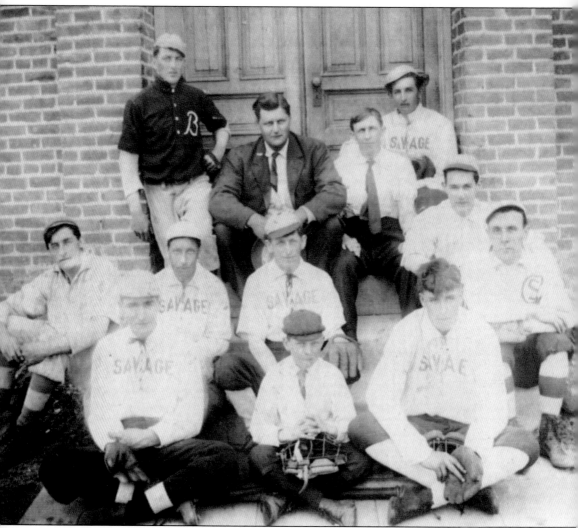

The 1912 Savage team included, from left to right, (first row) George Allen, Speck McCarr, and George Coakley; (second row) Bill Lannon, Mike Kennedy, Mike Zeller, Ray Coakley, and Tom Fahey; (third row) ? Kornerder, George Kline, Ed Hanson, and Tom Duffy.

Seven

SCHOOL DAYS

By a strange twist of fate—or more accurately, state law—the city of Savage is one of many municipalities in the state that does not have one school district. This is because school district lines were drawn up based on where the largest landowners lived. Thus, students from the city of Savage attend four different school districts: Burnsville-Eagan-Savage, Prior Lake-Savage, Shakopee, and Bloomington. Today, there are five public elementary schools, one private catholic school, one charter school, one junior high school, and one high school in the city limits. Most students from Savage attend elementary school within the city limits, but depending on where they live, they might attend junior high in Savage, Prior Lake, or Shakopee and high school in Prior Lake, Burnsville, or Shakopee.

But the boundaries on a map have not impacted the bond people form with their schools. The oldest of the group is M.W. Savage Elementary School, which was originally named Savage School when it was built in 1951. As the populations of Savage and Glendale grew together, more schools have been built to meet the community's needs.

This is a copy of the bond sold for school district 67, dated September 24, 1900. The bond is between school district 67, in Scott County, and Michael Allen.

The students who attended school in 1923 in Savage gathered for a photograph with their teacher, Miss Brennan. They are, from left to right, (first row) Maybelle Hanson, Dorothy Graphener, unidentified, and Mary Zeller; (second row) Michael Loftus, Mark Egan, James Allen, ? Allen, Roman Arnoldy, Anthony (Tony) McQuiston, and Ralph Hanson; (third row) unidentified, Martin McQuiston, unidentified, Arthur Williams, and Miss Brennan.

Savage Public School's two-story brick building was located on the northeast corner of Lynn Avenue and 125th Street. There was one classroom for the first through third grades on the first floor and one classroom for fifth through eighth grade on the second floor. The building was built in the late 1800s and was used until 1950.

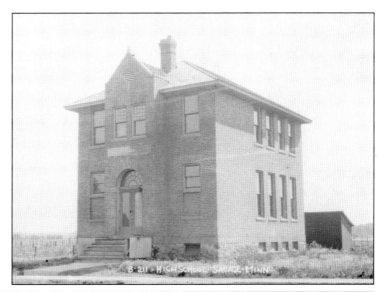

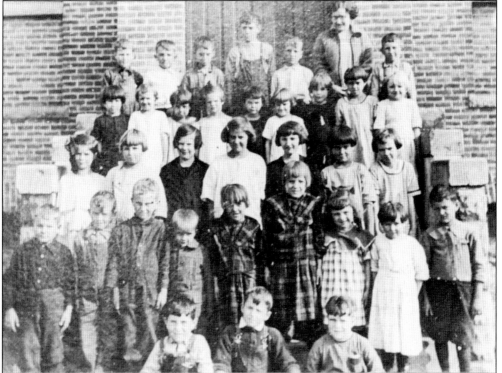

Mary Murray taught at the Savage School during the 1925–1926 school year. The student body was growing and included, from left to right, (first row) Frank Egan, Ray Raymond, and Harold McQuiston; (second row) Robert Rockwater, Kenneth Sanford, Jerry Allen, Andy Olson, Dorothy Olson, Mary Olson, Dorothy Stevens, Irene Broos, and Earl Kline; (third row) Bernice McQuiston, Mary Broos, Alice Williams, May Raymond, Margaret Loftus, unidentified, and Doris Hanson; (fourth row) Mary Egan, Lola Hanson, Mildred McCarthy, Mary McQuiston, Eunice McDonald, Peggy Barter, Ruth Hanson, Margaret McCarthy, and Margaret Riley; (fifth row) Axel Hanson Jr., Earl Barter, Robert Lattery, Kenneth Lattery, George Olson, Miss Murray, and Tony Egan.

113

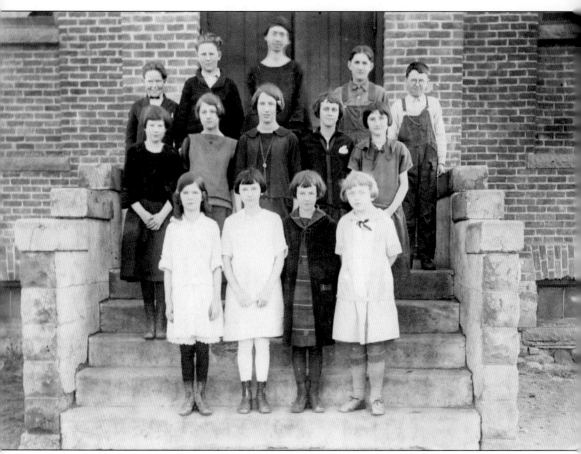

In 1924, Savage School students gathered on the front steps for a photograph. The students included, from left to right, (first row) Bernice McQuiston, Mary Sheridan, Doris Hanson, and Marstella Garvey; (second row) Alice Williams, May Raymond, Mary Zeller, Maybelle Hanson, and Margaret Loftus; (third row) Anthony (Tony) McQuiston, Edward Allen, teacher Alice Condon, Michael Loftus, and Bud Hanson.

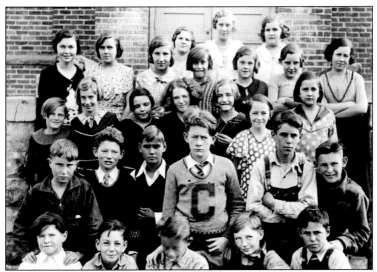

In 1932–1933, the student body at Savage School included, from left to right, (first row) Walter McQuiston, Alrid Mueller, Charles McCarthy, Glynn Riley, and George "Skipper" Coakley; (second row) George "Sonny" Allen, Robert "Red" Riley, Warren Butler, Pat O'Connell, James Lattery, and William Schneiderhahn; (third row) Alice McQuiston, Rosemary Schneiderhahn, Kathleen Cook, Marcella Allen, Edith Butler, Marion Cook, and Alice Egan; (fourth row) Eunice McDonald, Carol Hanson, Mary Allen, Virginia Coakley, Margaret O'Keefe, Helen Riley, and Marion Hynes; (fifth row) Florence McQuiston, Dorothy Cook, and Irene Broos.

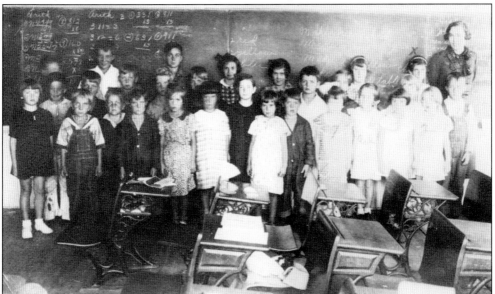

This photograph was taken in 1936 in the old brick school in Savage. There were names written on the back in pencil, but some were only initials and others were partial names. The list, in no particular order, includes teacher Mary Hayes, W.K., T.W., J. Ring, Rita O., Jane Egan, Gerry W., Alice K., Ceil Egan, Jane Allen, Earl McQuiston, G. Havican, L. Coakley, Donna Coakley, Yvonne Whitley, M. Williams, Lorraine T., Carol Coakley, Raymond Boggie, Eddie McQuiston, Peter Allen, Donald W., Raymond Oelson, Jack Cook, Raymond Egan, Donald Oelson, Leonard Havican, Madeline McCarthy, Bobby T., and A. Havican. (Courtesy of Ray Egan.)

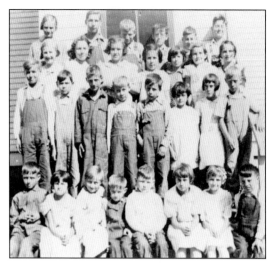

Students from Burnsville and Glendale Township attended Burnsville district 16 in 1933–1934 in Dakota County. The school was located on Burnsville Parkway and Upton Avenue. Pictured here are, from left to right, (first row) Bernard Neimeyer, unidentified, Catherine Kearney, Robert Kearney, James McCoy, Agnes Egan, Laura Neimeyer, and Wallace Egan; (second row) Joseph Korba, two unidentified, John Kearney, James Streefeland, unidentified, Helen Egan, and Cletus Giles; (third row) Mary Clare Kearney, Patricia Foley, Mary Streefeland, Doloris Streefeland, Mary Kelleher, Dolores Egan, and Alice Egan; (fourth row) Marcella Neimeyer, Ray Giles, Ardell Giles, Eugene Kearney, Frank Kearney, and Robert Egan. This photograph was taken by their teacher, Agnes Kelleher.

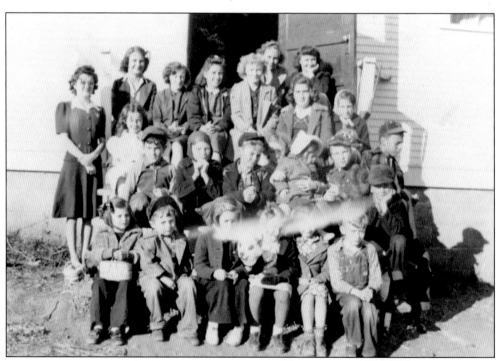

This 1943 class photograph from Burnsville school district 16 includes, from left to right (first row) Mildred Egan, Ronald Harkins, Luella Egan, Kathleen Hayes, Marge Kearney, and Jack Hayak; (second row) Rosemary Harkins, Ted Egan, Donald Egan, Elroy Hennen (holding the baby), Deloris Kearney, Donald Hayes, and Cleon Hennen; (third row) teacher Mary Suel Kearney, Julia Egan, Anna Therese Foley, Joyce Peters, Betty Kearney, Shirley Pickus, Mary Jane Egan, Roseann Kearney, and Virginia Foley.

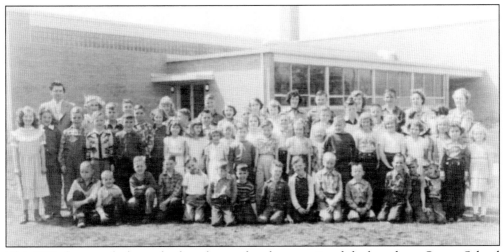

This 1951 photograph shows the first classes of students to attend the brand new Savage School in school district 67. The schoolteachers were Mr. McCoy, Mrs. Bailiff, and Mrs. Williams. By 1954, Savage Elementary became part of district 15. In 1956, six classrooms were added to the original building. In 1961, the gymnasium and library were added, followed by an addition of eight classrooms in 1963. A new office addition was constructed in 1967 and, in 1971, a music room was added and the kindergarten classrooms were remodeled. In 1988, the school was renamed M.W. Savage Elementary School after a proposal to change the name of the school became a study of the history of the area. While some parents questioned the name "Savage" on a school, community members insisted the name remain. As a result, the school's name was changed to include the full name of the city's namesake. The school underwent other renovations and additions in the early 1990s.

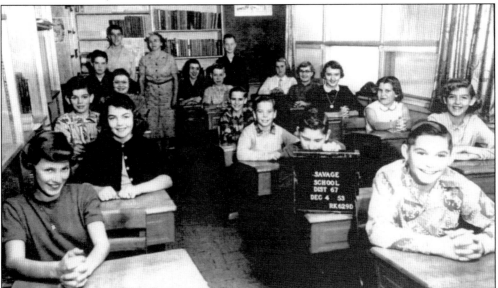

These students were part of a class at M.W. Savage School in 1953. Pictured are, from front to back, (left row) Marie Knebel, Shelby Poole, Francis Kennelly, Nancy Oster, and Mike Kepner; (middle row) Bob Lattery, Gene Knopf, Jerome Allen, Wilfred Williams, Ambrose Hauer, and Ruth Veenhuis; (right row) Pat Porter, Audrey Shelton, Janet Bohn, JoAnn Knopf, and Peggy Marble; (standing, from left to right) Bob Mueller, Mrs. Blaubaum, and Jens Bohn.

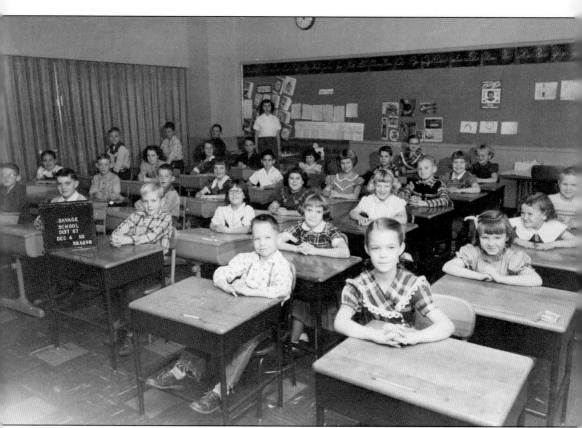

Teacher Rosemarie Muelken's class at Savage Elementary in 1953 included second- and third-graders. Pictured are, from left to right, (first row) second-graders Barbara Fuglum, Kathleen Pool, Jo Marie Dobel, Dennis Oian, and Michael Peters; (second row) Thomas Henderson, Susan Knebel, Jeanne Farnquist, Bruce Birdsall, Nancy Allen, and Mary Ann Korba; (third row) Robert Crider, Betty Brick, Joyce Colgan, Lynn Shafer, Don Swendra, and Beverly Fuglum; (fourth row) third-graders Clifford Veenhuis, Bob Toofe, Mary McQuiston, James Campbell, and Patricia Shelton; (fifth row) Terry Kearney, James Hauer, Kathleen Peters, Patty Muhlenhardt, and Karl Bohn; (sixth row) Judy Malmin, Ken Klotz, Bob Walters, and King Kennelly. Paul Williams was also part of the class but is missing from the photograph.

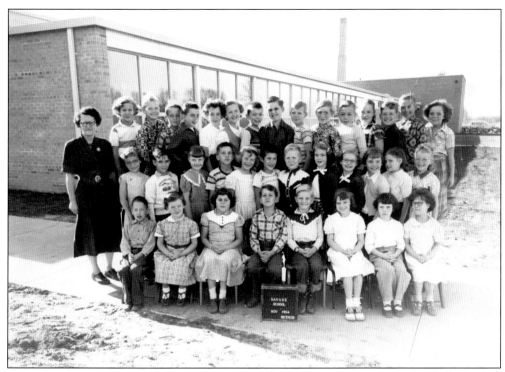

Lillian Williams is pictured with one of her classes at Savage Elementary in November 1954. Pictured are, from left to right, (first row) Tom Henderson, Jo Marie Doebel, Joyce Colgan, unidentified, Robert Crider, Kathy Poole, Patsy Shelton, and Betty Brick; (second row) unidentified, Jimmy Campbell, unidentified, Mike Peters, Jeannie Farnquist, Barry Mott, unidentified, Barbara Fulgum, Bev Fulgum, Nancy Allen, Sue Knebel, and Mary Ann Korba; (third row) Lillian Williams, Lynn Shafer, Ken Anderson, Karl Bohn, Don Swendra, Kathy Peters, Patty Muhlenhardt, Bob Walters, Paul Williams, unidentified, Jim Hauer, Ken Klotz, Judy Malmin, Terry Kearney, unidentified, and Mary McQuiston.

In 1954, this group of second-graders posed for a picture at Savage Elementary School. Pictured are, from left to right, (first row) Lilly Shelton, Betty McQuiston, Linda Rackow, Larry ?, Nancy Boche, Richard Dwyer, Joe Knebel, and Mary Kay Kearney; (second row) Kathy Egan, Evangeline Hauer, Scott Laquay, Sue Sprank, Christy Campbell, Rita Mueller, Mike Schunk, Ken Anderson, Jim Pivec, and Buddy Keller; (third row) teacher Lillian Williams, Cheryl Birdsall, Danny Straton, Mary Kaye Klotz, Steve Mullenhart, Jack Bergman, Marcus Bohn, Clyde Thurston, David Gehrls, Dixie Thurston, Alan Mott, Carol Farnquist, and Sharon Swendra.

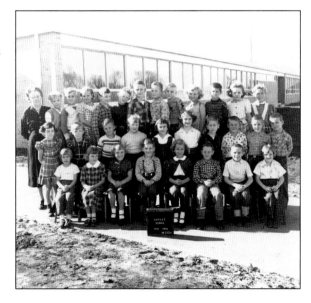

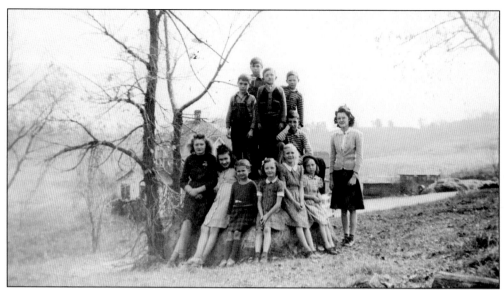

This photograph shows students who attended McColl's School in 1942, including, from left to right, (first row) Fern McColl, Annette McColl, Barbara McColl, Joanne Connelly, Dorothy Breegemann, and Clara Breegemann; (second row) James Breegemann, Donald Breegemann, Charles "Buzz" McColl, Bruce McColl, and Gerald Connelly. Teacher Mary Suel Kearney is in the plaid skirt on the right.

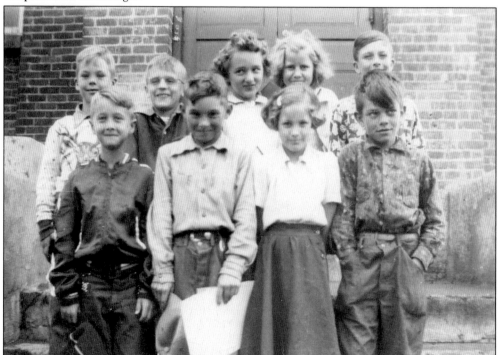

First- and second-graders in 1947–1948 pose in front of the school including, from left to right, (first row) first-graders Jens Bohn, Bob Lattery, Marie Knebel, and Francis Kennelly; (second row) first-grader Jerome Allen and second-graders Wilfred Williams, Janet Bohn, Audrey Shelton, and Bob Mueller.

Eight

FLOOD OF 1965

For many cities along the Minnesota River, the spring of 1965 brought the flood of the century. There have been other floods, but the flood of 1965 still holds the record. The recipe for disaster included a very snowy winter and a warm, rainy spring.

In Savage, village trustee Cleve Eno agreed to serve as flood coordinator. Eno remembered going out to survey the area with John Eibs, who he referred to as "the best blade man" around. They came up with a plan and cut a trench, which served as the edge of the dike. They then alternately filled the trench with black poly and dirt to create the base. The dike stretched down the north side of Highway 13 from Cargill property to the railroad trestle.

The Credit River was diked with sandbags as well. But that was not quite enough, something village officials learned as they mounted an all-out effort to keep floodwaters out of downtown with the help of volunteers from the town and nearby Burnsville High School.

The Huntley-Brinkley NBC-TV newscast carried the Savage flood story. The news team, just back from Vietnam, visited the city and was given a tour of the flood area by local officials.

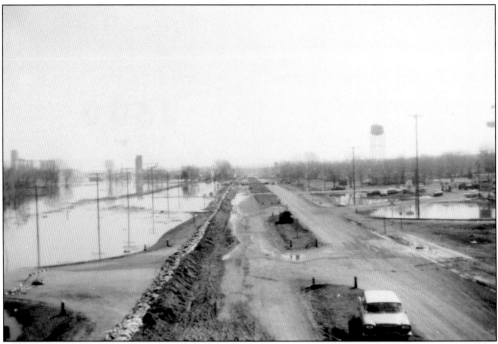

This dike, which stretched along Highway 13, stopped the Minnesota River from washing into downtown Savage.

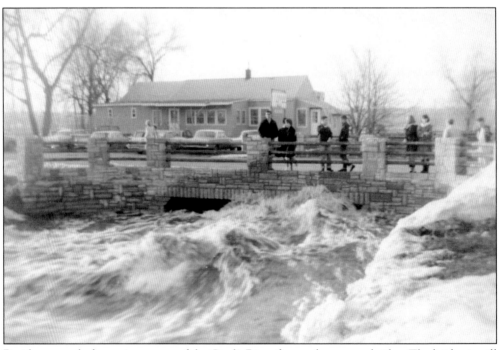

Residents watch the raging waters of the Credit River from a downtown bridge. The bridge is still there and carries traffic on 123rd Street between Quentin and Princeton Avenues.

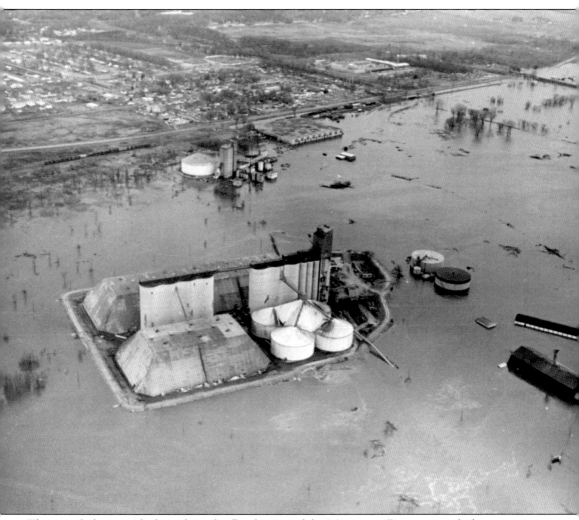

This aerial photograph shows how the floodwaters of the Minnesota River overtook the area to the north of Highway 13. A protective dike was constructed around Elevator C at Cargill (center) during the flood. Although the company had an earthen dike protecting all of its buildings and operations, it was overtaken by the rising water. Elevator C contained substantial quantities of stored commodities that could not be moved to safety.

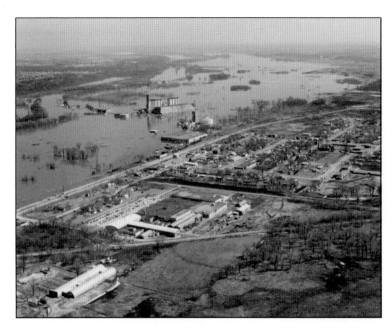

Another aerial photograph shows how the dike helped keep Savage dry. Since all the river crossings in the area were underwater, motorists had to travel Highway 13 to the Mendota Bridge. At times, traffic was backed up to Burnsville High School and stopped moving completely.

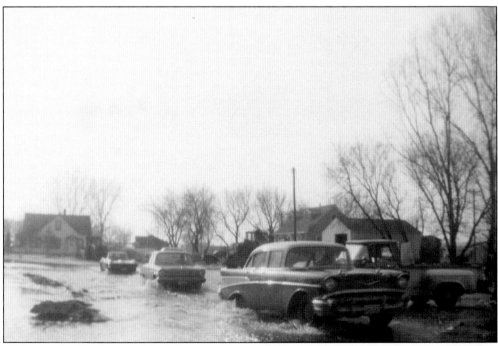

Although the floodwater of the Minnesota River were kept at bay, the Credit River went over its banks in many areas, but the flooding was not bad enough on local streets to stop traffic from moving along.

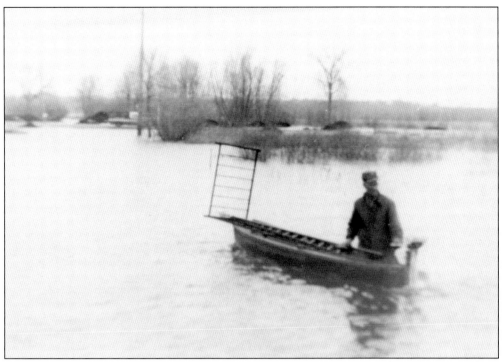

The flood did not stop R.G. "Bud" Roberts from retrieving products, such as this iron railing, from the Anchor Iron Company in Savage. He used a duck boat to get between Anchor Iron Company and Highway 13. His truck can be seen parked up on the road in the background. (Courtesy of Mark Roberts.)

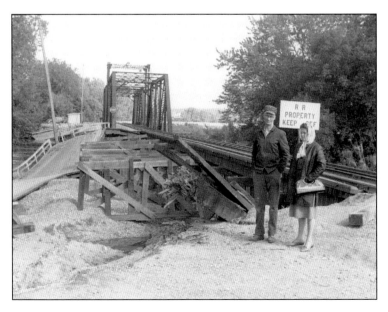

The flood took out one of the only crossings of the Minnesota River— the swing bridge that M.W. Savage built between Bloomington and Savage. This photograph shows R.G. and Jane Roberts on the Bloomington side of the river. (Courtesy of Mark Roberts.)

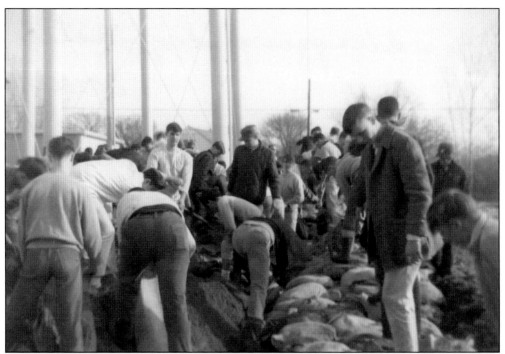

Volunteers lay down sandbags to protect against flooding. The Credit River had already backed up and flooded Elm Street (now Quentin Avenue). Volunteer firefighters sandbagged around the Credit River and broke up a jam of debris and ice under a small bridge, but the water was coming in too fast. With the help of residents and students from Burnsville High School, the floodwaters, which topped 21.4 feet on April 15, were kept at bay. Flood stage in Savage is 698 feet above sea level and the 1965 record of 719.40 feet has not been approached since.

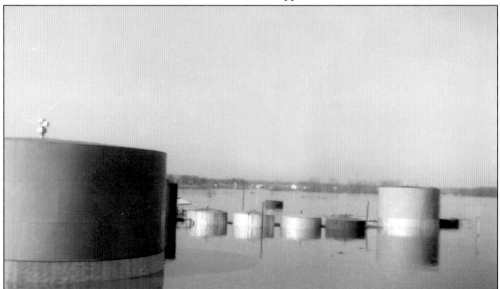

The oil storage tanks at Richard's Oil were surrounded by flood waters when the Minnesota River hit historic levels in the spring of 1965. Floodwaters also surrounded other businesses along the river, including Continental Grain and Savage Ready Mix.

126

Mayor Merrill Madsen Jr. and Dan O'Connell, the village attorney, are shown manning phones during the crisis. (Courtesy of the *Minnesota Valley Review*.)

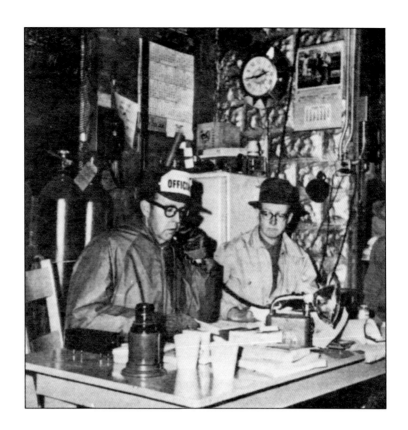

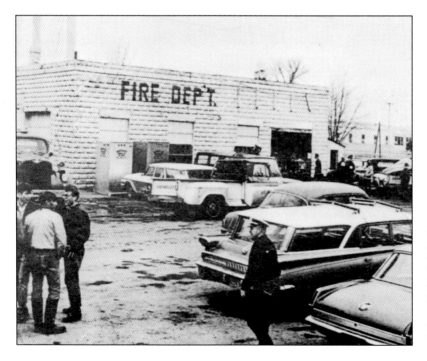

The Savage Fire Department served as the headquarters for flood control. (Courtesy of the *Minnesota Valley Review*.)

Discover Thousands of Local History Books
Featuring Millions of Vintage Images

Arcadia Publishing, the leading local history publisher in the United States, is committed to making history accessible and meaningful through publishing books that celebrate and preserve the heritage of America's people and places.

Find more books like this at
www.arcadiapublishing.com

Search for your hometown history, your old stomping grounds, and even your favorite sports team.